LITERARY CHICKENS

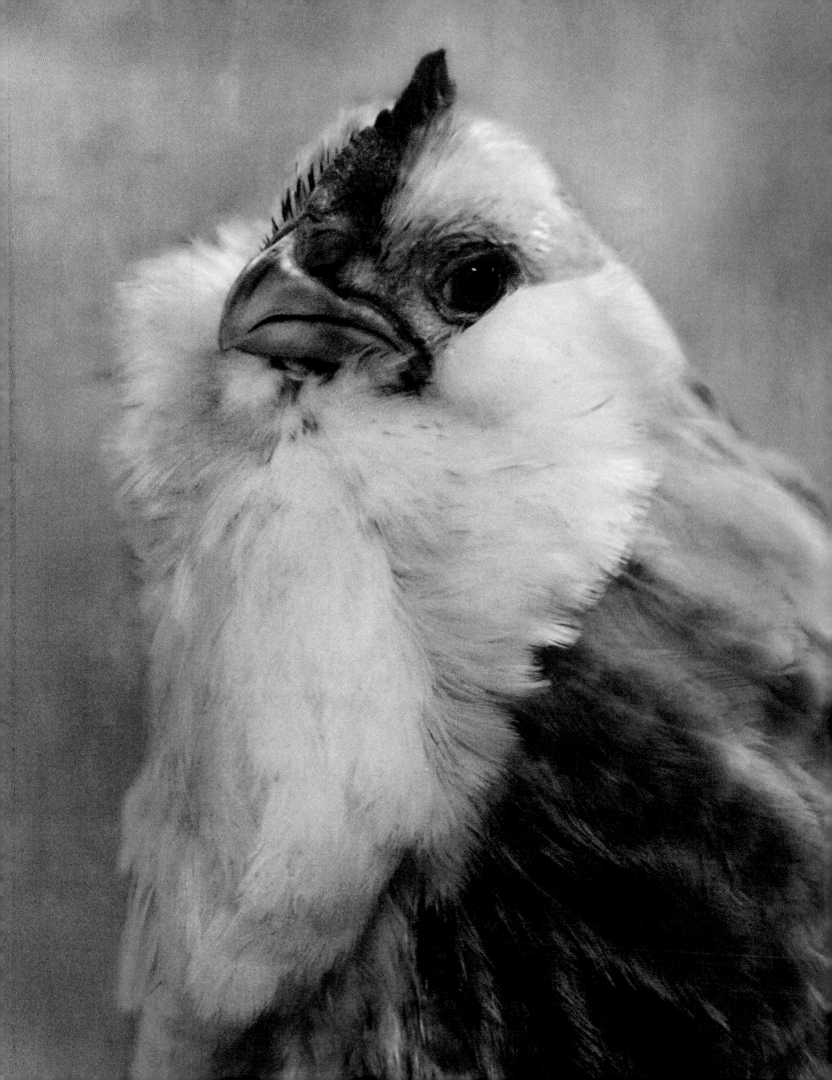

PHOTOGRAPHS AND
LITERARY SELECTIONS BY
BETH MOON

Literary Chickens

FOREWORD BY
ISABELLA ROSSELLINI

AFTERWORD BY
JANE GOODALL

ABBEVILLE PRESS PUBLISHERS
NEW YORK LONDON

For more information on Beth Moon's platinum prints, visit bethmoon.com.

Front cover: Reza Asil male. See page 105.
Back cover: Ameraucana female. See page 49.
Page 2: Salmon Faverolles female. See page 41.

EDITOR: David Fabricant
PRODUCTION EDITOR: Matt Garczynski
DESIGNER: Misha Beletsky
PRODUCTION MANAGER: Louise Kurtz

First edition
10 9 8 7 6 5 4 3 2 1

Library of Congress Cataloging-in-Publication Data

Names: Moon, Beth, author, photographer.
Title: Literary chickens : photographs and literary selections / by Beth Moon ; foreword by Isabella Rossellini ; afterword by Jane Goodall.
Description: First edition. | New York : Abbeville Press Publishers, [2018] | Includes index.
Identifiers: LCCN 2018026350 | ISBN 9780789213099 (hardcover)
Subjects: LCSH: Chickens--Pictorial works.
Classification: LCC SF487.3 .M66 2018 | DDC 636.5--dc23
LC record available at https://lccn.loc.gov/2018026350

For bulk and premium sales and for text adoption procedures, write to Customer Service Manager, Abbeville Press, 655 Third Avenue, New York, NY 10017, or call 1-800-ARTBOOK.

Visit Abbeville Press online at www.abbeville.com.

CONTENTS

Foreword by Isabella Rossellini 7

Introduction by Beth Moon 9

Chickens As They Are by Melissa Caughey 12

Literary Chickens 17

Toward a Cultural History of the Chicken

by Collier Brown 123

Afterword by Jane Goodall 129

Acknowledgments 131

Breeds Pictured 132

Works Quoted 134

FOREWORD

BY ISABELLA ROSSELLINI

One day I received a package in the mail accompanied by a note. It was signed with a lovely name, and that was the first thing I liked about her: Beth Moon.

The package contained a book entitled *Ancient Skies, Ancient Trees*. Looking through the book, I wasn't sure if I was looking at photographs or paintings. I thought I could feel what Beth Moon felt. Like me, she is enthralled by Nature. If there is a difference between the two of us, it's that Nature makes me laugh, while Beth is totally enchanted by it. Her images have a fairy-tale quality to them.

The package also contained a few photos of chickens. Surprisingly, the photos were in black and white. I was surprised, because chickens have beautiful, colorful feathers and that's the way I'm used to seeing them. But without color, I could see things that had at first escaped my eyes: their elegant bearing, their strong expressions, and the ethereal quality and texture of their feathers. By eliminating the color, Beth allowed me to see the chickens' beauty in a deeper way.

When I read the note, I was flattered to no end. "Could I come to your farm to photograph your heritage chickens?" I live on a small artisanal farm on Long Island, New York. I have about a hundred chickens, most of them endangered breeds. Yes, you read the last sentence correctly. Farm animals are also in danger of extinction. Industrial farming raises billions of chickens a year, but only one or two breeds of chickens, while others are forgotten.

It would be as if we decided to just have one breed of dog, let's say the Chihuahua, and renounced all other breeds. No more Labradors, herding dogs, poodles, Jack Russells—it would be a great loss of diversity. Well, this is what happens with industrial farming. Just as we lose diversity in our produce, eating only, for example, one type of spinach or one type of asparagus, the same is happening with animals.

Beth wanted to come to my farm to photograph diversity. Of course, I wrote back with an enthusiastic "Yes, please come!" As a model and actress all my life, I have been photographed a lot, so I know how it feels to be in front of the camera. I wondered how my chickens would feel.

Beth arrived a few weeks later with her daughter Alexandra. Along with their photographic equipment, they brought a low table where the chickens were to stand and "pose." I wondered how my chickens would react. Poor things, they know they are prey and everyone wants to eat them, so they evolved to be alert and flighty. But Beth and her daughter's calmness and kindness had an effect on them. My chickens didn't panic, they didn't scream and run under bushes and fly up to the top of trees. They hung around them and the camera with great curiosity and maybe (who knows) were even flattered by all this attention.

INTRODUCTION

LITERARY CHICKENS: *GALLI LITERATI*

BY BETH MOON

This story starts with the chicken.

A message is sent from the hen's brain to the ovary.
Twenty-four hours later an egg is laid.
A perfect incubator that holds a secret, a message;
the magic of life.

The creative process can be very curious. It is interesting to note the impetus for a body of work and the form it ultimately takes. In 2007, I attended an event at a friend's ranch in California. Inspiration came in the form of the speaker who addressed the group after dinner.

Writer and activist Michael Pollan spoke about many issues, but what stood out for me were topics like factory farming and the treatment of farm animals. The industrialized farm movement has severed our traditional connection with animals, making them almost invisible to us. It is all too easy to forget about the lives and experiences of our farm animals, especially that most engineered of all domestic animals, the chicken.

I wanted to create a body of work that would bring the chicken back to the forefront of our attention, and make it harder for us to accept the cruelty that is part of the food industry. I decided to do this not by focusing on the negative aspects of animal welfare, but by elevating our perception of the chicken.

Attempting to photograph a friend's chickens gave me a good idea of how challenging this project would be. They were constantly on the move and often ran away. Every now and then I would fleetingly catch their gaze. Patience!

Reviewing the results, I saw many empty frames, but the few images that I did capture conveyed a startling range of emotions and personalities. It was not my goal to anthropomorphize the birds, to find expressions or qualities similar to those of humans; but on the other hand, by ignoring their humanlike characteristics, we risk seeing them as separate and miss something fundamental about the animals and ourselves. Empathy has an important part to play in our understanding of our relationship with animals. By recognizing our similarities, we begin to view these animals as individual beings that deserve respect, and that is a good first step.

Encouraged by these initial shots, I received referrals from other chicken owners and discovered a burgeoning urban farming movement with the chicken at its center. Gardening and raising chickens often went hand in hand, and many backyard chicken farmers told me how gratifying it is to collect eggs from birds that you know are living a happy life.

One such enthusiast was actress and filmmaker Isabella Rossellini, who raises heritage-breed chickens on her very picturesque farm on Long Island. There I found many animals free to roam, living a life that I can only describe as pastoral bliss. Concerned with sustainability and animal welfare, Rossellini believes there is a role for each small farm to play, an opportunity to bolster genetic diversity.

Watching the birds in the open gave me a better idea of their natural expression. I marveled at what looked like an exaggerated collar on one, seemingly more suited to a runway model than a chicken. Some were bearded, while others had muffs, long feathers similar to muttonchop whiskers. Together they made a motley crew. Highly inquisitive, they rushed over to greet me and investigate the noise my camera bag made.

The distinguishing features of these creatures are many, but it is the feathers that captivate. There is something grand and magical about feathers, the sunlight intensifying their iridescent shimmer. Intricate feather patterns and exotic plumage evoke a sense of glamour. Hardly less fascinating are their lavish combs, recalling crowns worn by nobility. A curious tilt of the head and an anxious gaze reveal a link to the chicken's evolutionary past, to its ancient dinosaur ancestors alive 145 million years ago.

How strange some of the more exotic breeds of chicken must have seemed to early explorers. One particular breed known for its unusually fluffy and silky plumage, the Silkie, was referred to as a "furry chicken" in Marco Polo's account of his travels through Asia in the thirteenth century. In 1598, the Italian writer and naturalist Ulisse Aldrovandi described Silkies as "wool-bearing chickens" and "clothed with hair like

that of a cat." It is not known exactly where this breed first appeared, but it was well documented in ancient China. Early Dutch breeders told buyers that Silkies were the offspring of chickens and rabbits and claimed that they had actual mammalian fur.

My daughters assisted me in handling the chickens that I photographed. My make-shift outdoor studio consisted of a low table and a linen backdrop. I chose to strip these images down to essentials, without the distraction of color. Not many details are necessary to portray an essence. A large aperture created a shallow depth of field. The process of making exhibition prints—hand-coating large sheets of heavy cotton watercolor paper with a light-sensitive solution of platinum and palladium—further abstracted the images, resulting in tones of warm black, soft gray, and brown. Originally I titled this body of work "Augurs and Soothsayers," in reference to ancient Rome, where chickens and other animals were thought to reveal messages from the gods.

To paraphrase the Roman poet Horace, "a picture is a poem without words." This saying points not only to the ability of a picture to tell a story, but to a fundamental affinity between the written word and visual art. An image can expand the meaning and purpose of a text, and vice versa.

It seemed unusual, and yet somehow fitting, to pair the portraits of chickens with passages from classic literature. I tried to choose passages that reflected timeless themes, but which also included visually suggestive details and evoked customs and traditions of the past. Without the broader context of a storyline, these excerpts have an abstract quality; each hangs, as it were, in midair, creating its own smaller narrative—a literary cameo of sorts.

This project was satisfying to me on many levels. While spending time with these birds, I grew to understand them better—and as I got closer to them, in turn I got closer to a part of myself, with new awareness. It was a beautiful reminder that, in the natural world, we are all connected.

May we love the earth and all its creatures more.

CHICKENS AS THEY ARE

BY MELISSA CAUGHEY

*L*ooking at the remarkable black-and-white chicken portraits in this book, it is hard not to be struck by the uniqueness of each bird. How did they come to have such lovely and distinctive features? And is it true that chickens have individual personalities, like dogs?

Researchers believe that the first domesticated ancestors of our modern-day chickens hatched into being seven to ten thousand years ago, deep in the jungles of South Asia. Today there are more chickens than people on our planet, and they can be found everywhere. But contrary to what one might think, it wasn't their eggs or meat that made them go global. Rather, it was cockfighting. The Asil breed, for instance, originated between 1200 and 900 BC on the border between India and Pakistan and was bred for fighting. Through this sport, chickens quickly spread to other parts of the world, and people became fascinated with them.

By the mid-1800s, chicken keeping came to Europe's royalty. In 1842, Queen Victoria was presented with chickens as a gift. Victoria's birds were three times the size of today's chickens, laid gigantic eggs, and were loved by the queen. She hired a caretaker for her birds and had a fancy home created for them on the palace grounds. Once the queen started keeping chickens, it wasn't long until her fellow Britons began to follow suit. In those days, exotic chickens were a luxury item, sometimes fetching nearly ten thousand dollars per bird in today's money!

In 1845, the first British poultry show, which included chickens, geese, ducks, and pigeons, was held in London. Even Queen Victoria entered her chickens, and Charles Darwin his pigeons. These shows not only allowed guests to see an array of birds and socialize, but also led to an effort to curtail cockfighting, which was finally banned in 1849.

Across the pond, similar things were happening. America hosted its first poultry show at Boston's Quincy Market in 1849. More than fourteen hundred birds were entered. The following year over twelve thousand birds were entered, and a poultry association was formed. Both years, judging was canceled because it was too difficult to declare a winner without guidelines in place. It wasn't until 1874 that the first *American Standard of Perfection* was set forth by the American Poultry Association (APA) to serve as the poultry standard in North America. Still used today, this continually updated publication includes illustrations and descriptions of the APA's recognized breeds and varieties, and guidelines for judging.

Today the APA recognizes over one hundred chicken breeds, but breeds it has not yet recognized often have a special appeal. This is true of Switzerland's national breed, the Silver Spangled Appenzeller Spitzhauben. Fascination with novel chicken breeds is nothing new. Japanese Shamos, for instance, came to American soil in the most unique way: GIs returning from World War II carried home fertilized eggs in their pockets.

Like cats and dogs, chickens have been bred for numerous traits: temperament, tolerance of different climates, appearance, egg production, and size. So-called standard chickens range in size from the four-pound Sultan to the ten-pound Jersey Giant. Most standard breeds also have miniature counterparts, called bantams, which display all the traits of the full-size breed but usually weigh no more than a couple of pounds.

Chickens often produce beautifully colored eggs—blue, green, pink, and even a rich chocolate—and some lay large quantities per year. Some of the most productive hens include Leghorns, Australorps, and Rhode Island Reds. When well cared for, some hens can lay 280 eggs per year. A White Leghorn holds the record of laying 371 eggs over the course of 365 days! In our backyard, chickens lay eggs in twelve by twelve inch nesting boxes filled with pine shavings. When it is time to lay an egg, the hen hops into the nesting box, fluffs up the shavings, sits, and waits. She growls at others that dare to come near, because yes, she has a favorite nesting box. But often another hen will push her way into the box for a joint egg laying. Once a hen lays her egg, she sings a song to announce its arrival. *Buk, buk, buk, buk, buk—BAGAW!* The singing lasts for minutes, and sometimes hens that haven't even laid their egg yet will join in. It is an accomplishment celebrated by the entire flock.

A chicken's feathers are highly functional: they offer protection from the weather, allow for small bursts of flight, and may even be pulled from the chest to line a nest of

eggs. Feathers are also beautiful: every breed has uniquely colored, textured, and sometimes patterned feathers. Silkie Bantams are balls of fluff, while Frizzles look frazzled, with feathers that jut out and curl. Some chickens, like the Rumpless Araucana, are distinguished by their lack of tail feathers, while others, like the Polish breed, have poofs on the top of their heads. Then there is the Salmon Faverolle, a French breed. She is a bearded lady with cream and light brown colors with some black lacing. We have one, named Lucy. She is sweet and curious, and has the rare five toes on each foot. She has a deep voice and likes to talk. When we reply, she cocks her head from side to side, trying to grasp exactly just what we are saying to her.

Fleshy red wattles dangle beneath chickens' chins, and perched atop their heads are red fleshy combs. The comb is warm to touch in the summer, and cool in the winter. It is firm, a bit stiffer than your earlobe. Combs vary considerably in size, and are classified into eight different shapes: single, buttercup, cushion, pea, rose, strawberry, walnut, and V-shaped. (The V-shaped comb lends a distinctly sinister appearance to the White Sultan rooster.) Roosters have larger, showier combs and wattles than hens. These are attractive to females. The wattles and combs move and shake while the rooster does a dance accompanied by gestures called tidbitting, to entice a mate. Chickens have earlobes, too, which can be blue, red, or white. In some cases, you can tell the color of a chicken's eggs from that of its earlobes.

Chickens have incredible eyes that allow them to see using both monocular and binocular vision. Their superior vision is enabled in part by a unique form of matter that was first discovered in chickens' eyes: disordered hyperuniformity, which has characteristics of both a liquid and a crystal. Chickens' scaled legs have strong feet and claws for digging and warding off enemies. But the chicken's most useful asset is its beak. It grows like your fingernails, and requires regular maintenance and care, done by the bird. The beak is used for eating, grooming, defense, rearing young, and investigating the surroundings. The area of the beak located between the eyes is used for navigation, and taps into a magnetic compass that chickens have possessed since their days in the jungle.

Chickens have an undeniable physical beauty, but for me, their true beauty lies in their personalities. These birds are individuals, and that's why they're so much fun to watch. Observation reveals budding romances, comedies, and dramas. You can also learn a lot about teamwork, and belonging to a flock. It turns out that chickens do not like to be alone. They prefer the companionship of other chickens. They even flock

together with breeds unlike their own. They overlook their differences because they know that their survival is based on numbers and sticking together: they are more powerful against threats when in numbers than alone.

Chickens are quirky and curious, and love to explore. They are excellent problem solvers. Some of their favorite pastimes include digging for bugs and worms, and dining on ticks, small frogs, and even snakes. (Chickens are omnivores despite not having teeth.) They flit and hop about, simply happy to be alive. All day long they seek and explore, until about midafternoon, when it's time for a siesta, following their favorite grooming ritual, a dust bath. Working alone or with a partner, a chicken prepares the bath by digging a hole in the ground. Once satisfied with the hole, the chicken climbs in. She lies down on her side and with her wings and feet tosses dirt up into the air to land on her body. She contorts and wiggles and appears to go completely boneless. Sometimes I fear my chickens dead, but they are just napping in these holes as the warm sunbeams shine down on their feathers. When you are accompanied by a friend, a dust bath is even better. A friend can help groom you and pick off anything that you can't quite reach. This is chicken friendship at its best.

Chickens show incredible dedication to motherhood and fostering their young. For twenty-one days the mother hen sits on her eggs, while cooing sweetness to her shelled babies. She only leaves the nest once daily, for food and water, and to poop away from the nest. As the chicks hatch from the eggs, the mother coaches them. Roosters have been known to help sit on the eggs and even rear the chicks by showing them around, protecting them from danger, and teaching them the ways of life.

Chickens have their own individual routines. They will visit neighbors' yards, knock on the door to access the dog's food inside the house, and, without prompting, go to greet the kids as they get off the schoolbus. Chickens can also be clicker-trained to perform on obstacle courses, play the piano, dance, count, and recognize shapes and patterns upon request.

Chickens have become therapy pets for those in need, including elderly people in nursing homes. Therapy chickens spend their visits laying eggs in baskets lined with colorful hand-knitted afghans, perching upon walkers, and sitting in many laps. They seem to elicit a positive response even from patients with severe behavioral issues, memory loss, or physical limitations.

I was admittedly naïve when I started keeping chickens. I was worried about whether they would be docile enough to manage—I certainly had no idea that they would make

good pets. But where I lived, chickens were making a comeback. The chicken keepers I spoke to loved their flocks for so many reasons: they provided fresh fertilizer for the garden, dined on garden pests, and laid breakfast every day. I had to give it a try.

We took our first delivery of day-old chicks via the United States Postal Service, and it changed our lives. I soon found my family mesmerized in front of the makeshift temporary home for our new little babies. We put a beach blanket in front of the box and carved out a window for viewing. It was like watching television, only better! The chicks started to establish their hierarchy, the pecking order. Long before any of them started laying eggs, we had all bonded with our first flock: an Australorp, two Buff Orpingtons, and three Silkie Bantams—two blacks and one buff.

Years have now passed, and we still have our chickens. In fact, we are on our third flock and soon will have a fourth. The average lifespan of a chicken is between five and seven years, and hens lay the most eggs in their first two years. Some chicken keepers give away or sell their older chickens, once they start laying fewer eggs and their breeding potential is diminished. But for us, their value doesn't lie in feathers or eggs. It lies in friendships.

Our chickens have names. Most of the chickens know their names and come to us when called. They recognize each member of the family, and they even have their favorite people, whom they prefer to hang out with. They enjoy snuggling in the crook of my neck. They nuzzle in with their beaks, never seeming to get close enough. I can feel them exhale tiny puffs of air. I think this is how chickens give hugs. Despite being barren of eggs, our older chickens still have a respected place within the flock. They willingly sit on the younger hens' eggs when given a chance. They troubleshoot for their flockmates and teach them many things—especially how to sneak into off-limits areas of the garden. Mostly though, they become family friends.

I cried when I said goodbye to one of my first and favorite chickens, a spunky, talkative black hen named Tilly. I can still hear her voice, and sometimes I swear that I can feel her presence in the garden. She made me realize that chickens were special.

I've also come to realize that chickens are universal. They span all cultures, languages, climates, and ages. They have adapted to live in some of the most populated places on the globe, and in some of its remotest regions. For the human race, there is promise in the egg, of the future and its possibilities.

LITERARY CHICKENS

A henchman attended,

carried the carven cup in hand,

served the clear mead. Oft minstrels sang

blithe in Heorot. Heroes revelled,

no dearth of warriors, Weder and Dane.

—Anonymous, *Beowulf* (before A D 1000)

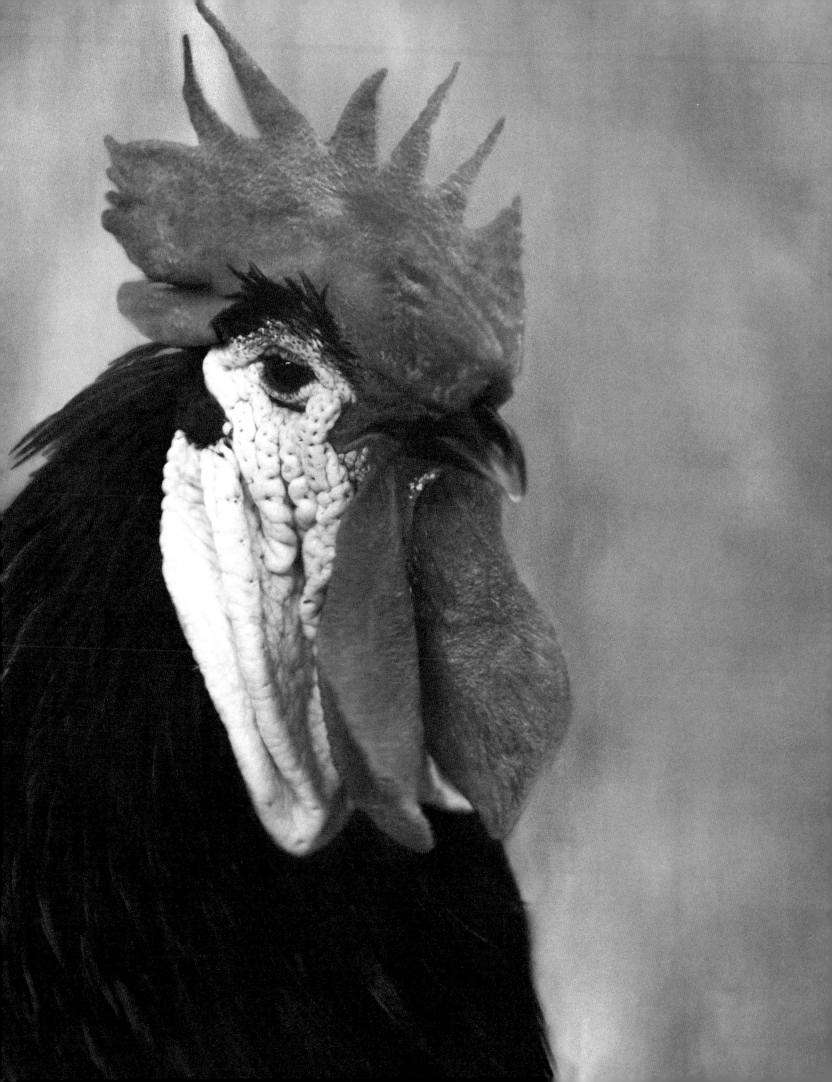

The Miller was a stout carle for the nones,
Full big he was of brawn, and eke of bones;
That proved well, for ov'r all where he came,
At wrestling he would bear away the ram.
He was short-shouldered, broad, a thicke gnarr,
There was no door, that he n'old heave off bar,
Or break it at a running with his head.

—Geoffrey Chaucer,
The Canterbury Tales (1387–1400)

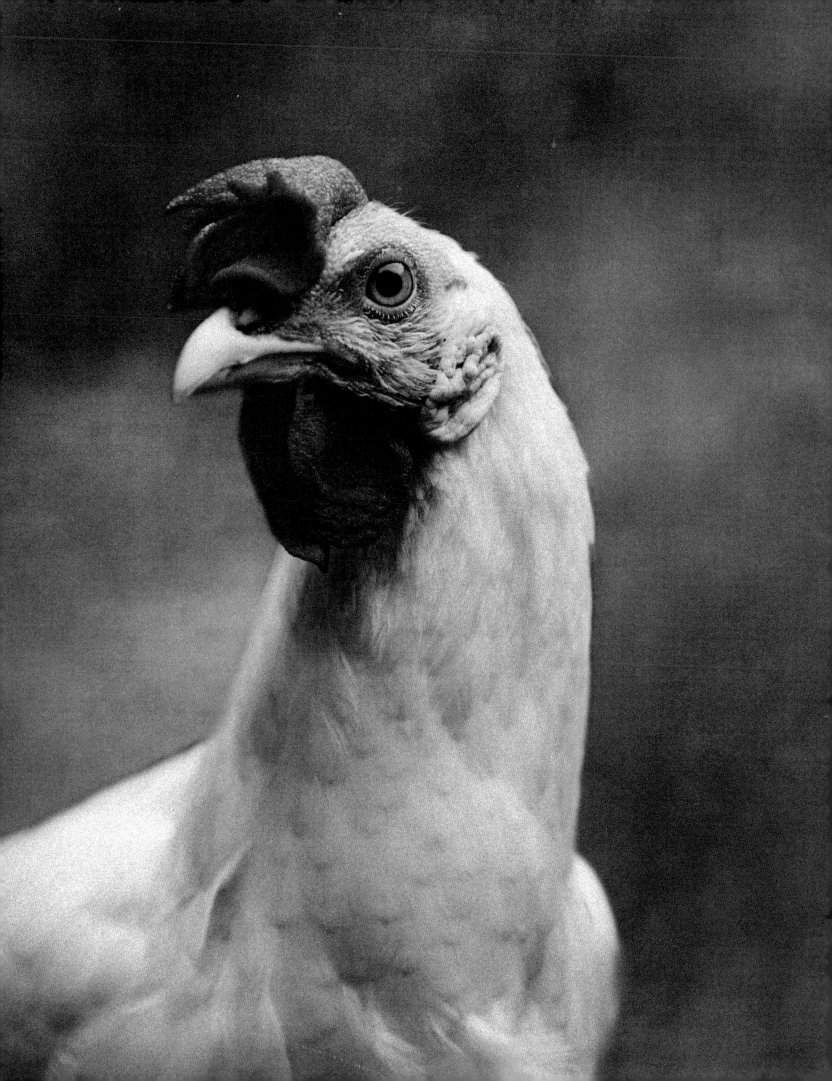

\mathscr{A} prince may rise from a private station in two ways, neither of which can be entirely attributed to fortune or genius. . . . These methods are when, either by some wicked or nefarious ways, one ascends to the principality, or when by the favour of his fellow-citizens a private person becomes the prince of his country.

—Nicolo Machiavelli, *The Prince* (1532)

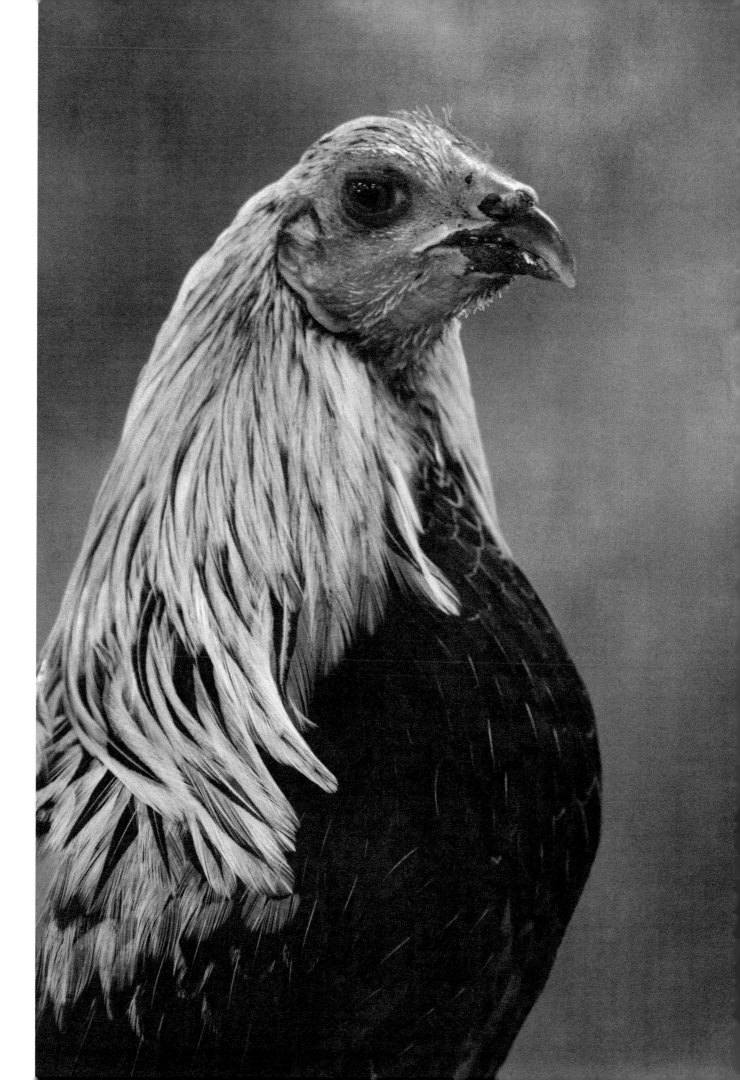

So then, his armour being furbished, his morion turned into a helmet, his hack christened, and he himself confirmed, he came to the conclusion that nothing more was needed now but to look out for a lady to be in love with; for a knight-errant without love was like a tree without leaves or fruit, or a body without a soul.

—Miguel de Cervantes, *Don Quixote* (1605)

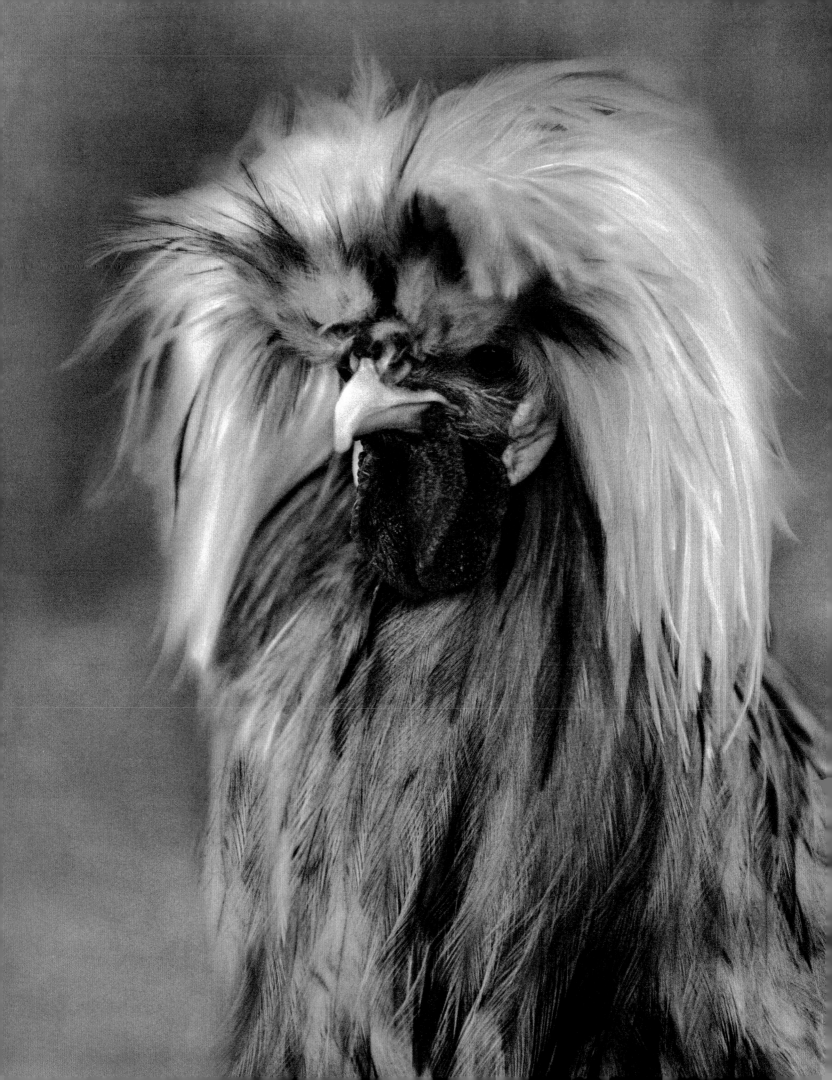

I grant I never saw a goddess go;

My mistress, when she walks, treads on the ground.

And yet, by heaven, I think my love as rare

As any she belied with false compare.

—William Shakespeare, Sonnet 130 (1609)

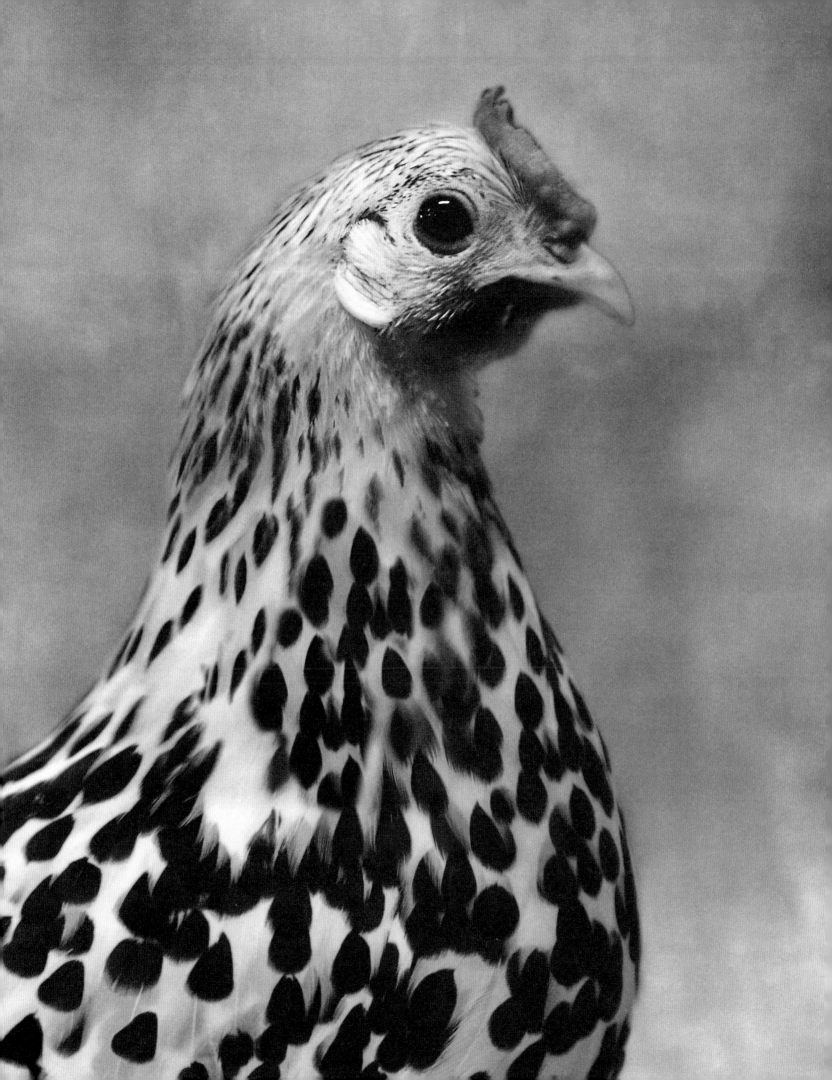

With grave

Aspect he rose, and in his rising seemed

A pillar of state; deep on his front engraven

Deliberation sat and public care;

And princely counsel in his face yet shone,

Majestic though in ruin: sage he stood

With Atlantean shoulders fit to bear

The weight of mightiest monarchies....

—John Milton, *Paradise Lost* (1667)

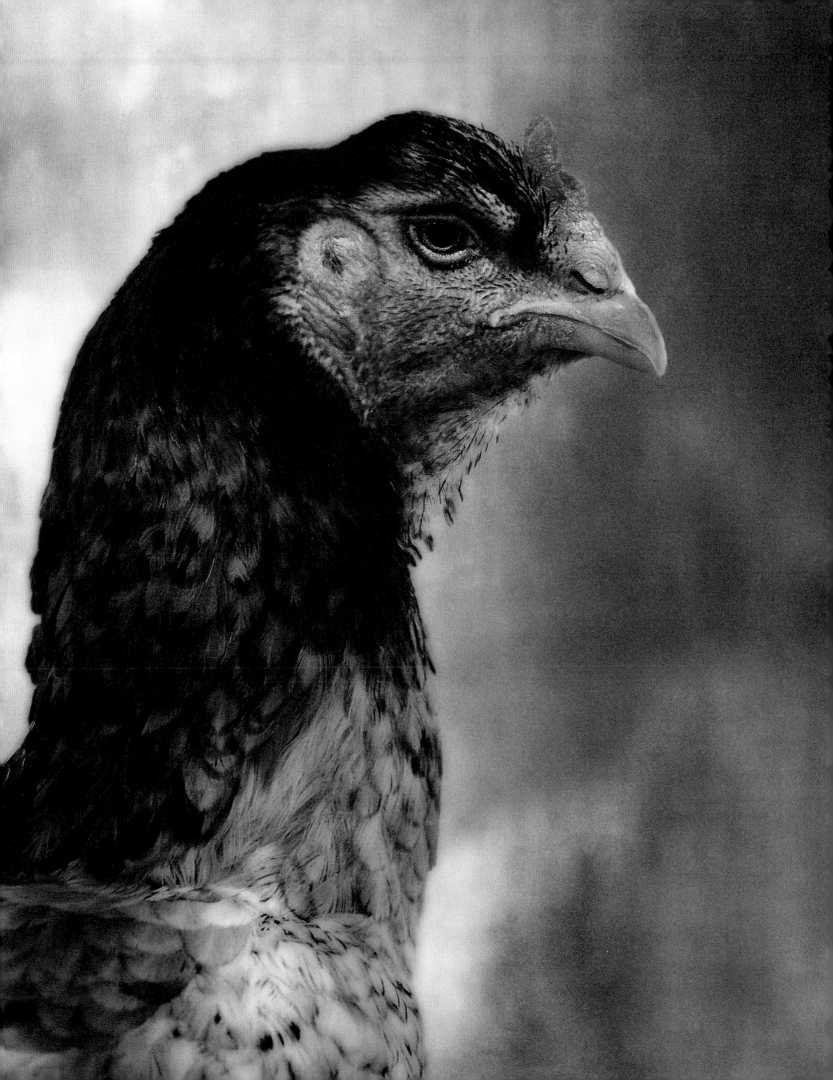

He put this engine into our ears, which made an incessant noise, like that of a water-mill: and we conjecture it is either some unknown animal, or the god that he worships; but we are more inclined to the latter opinion, because he assured us . . . that he seldom did any thing without consulting it. He called it his oracle, and said, it pointed out the time for every action of his life.

—Jonathan Swift, *Gulliver's Travels* (1726)

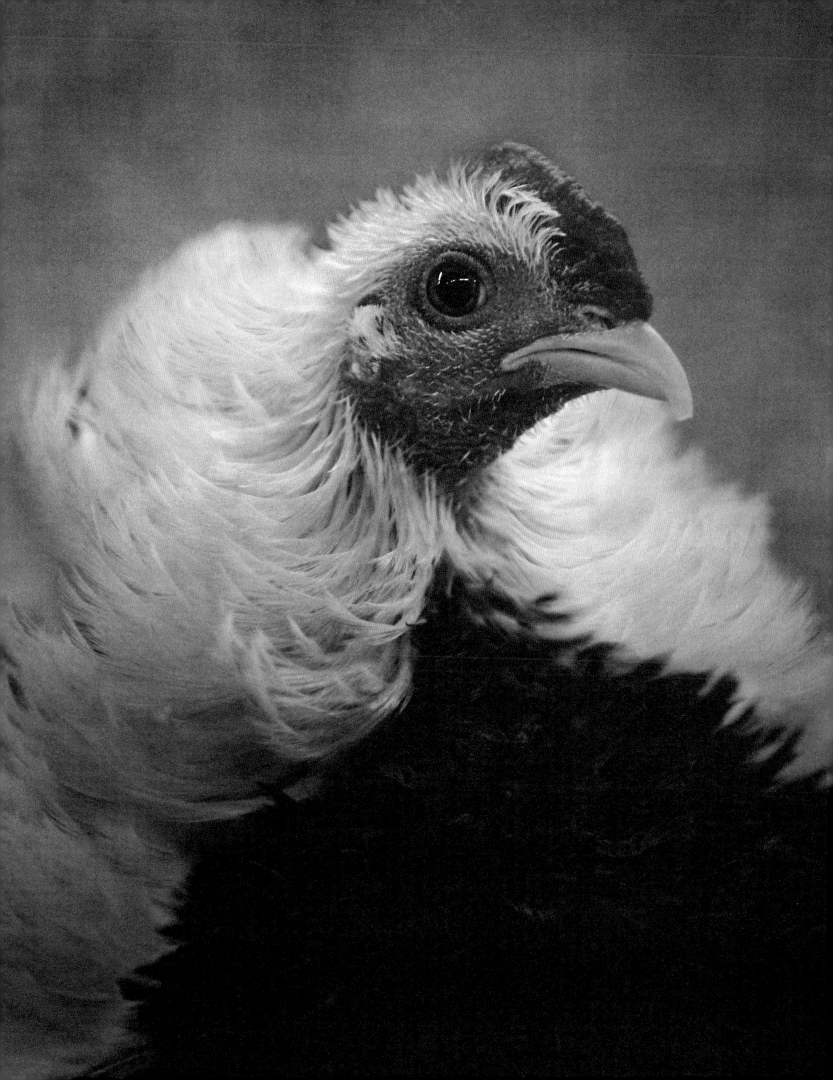

The Baron was one of the most powerful lords in Westphalia, for his castle had not only a gate, but windows. His great hall, even, was hung with tapestry. All the dogs of his farm-yards formed a pack of hounds at need; his grooms were his huntsmen; and the curate of the village was his grand almoner. They called him "My Lord," and laughed at all his stories.

—Voltaire, *Candide* (1759)

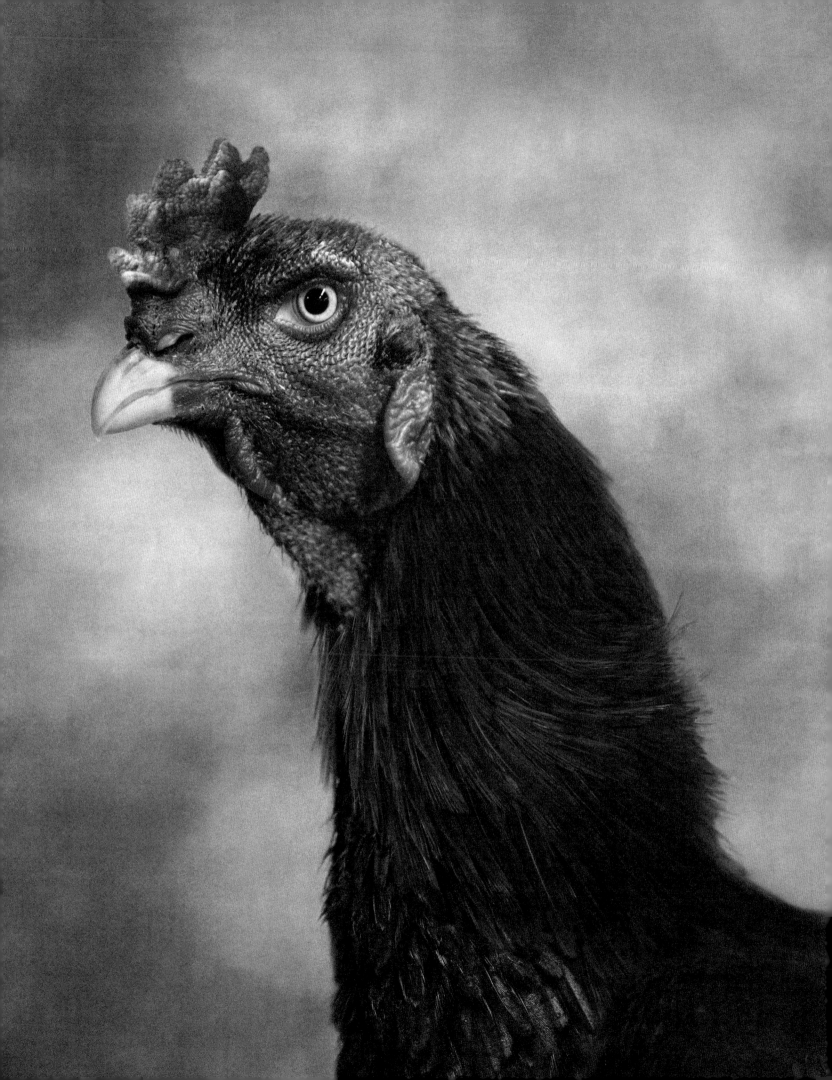

I've studied now Philosophy

And Jurisprudence, Medicine,—

And even, alas! Theology,—

From end to end, with labor keen;

And here, poor fool! with all my lore

I stand, no wiser than before.

—Johann Wolfgang von Goethe, *Faust* (1790)

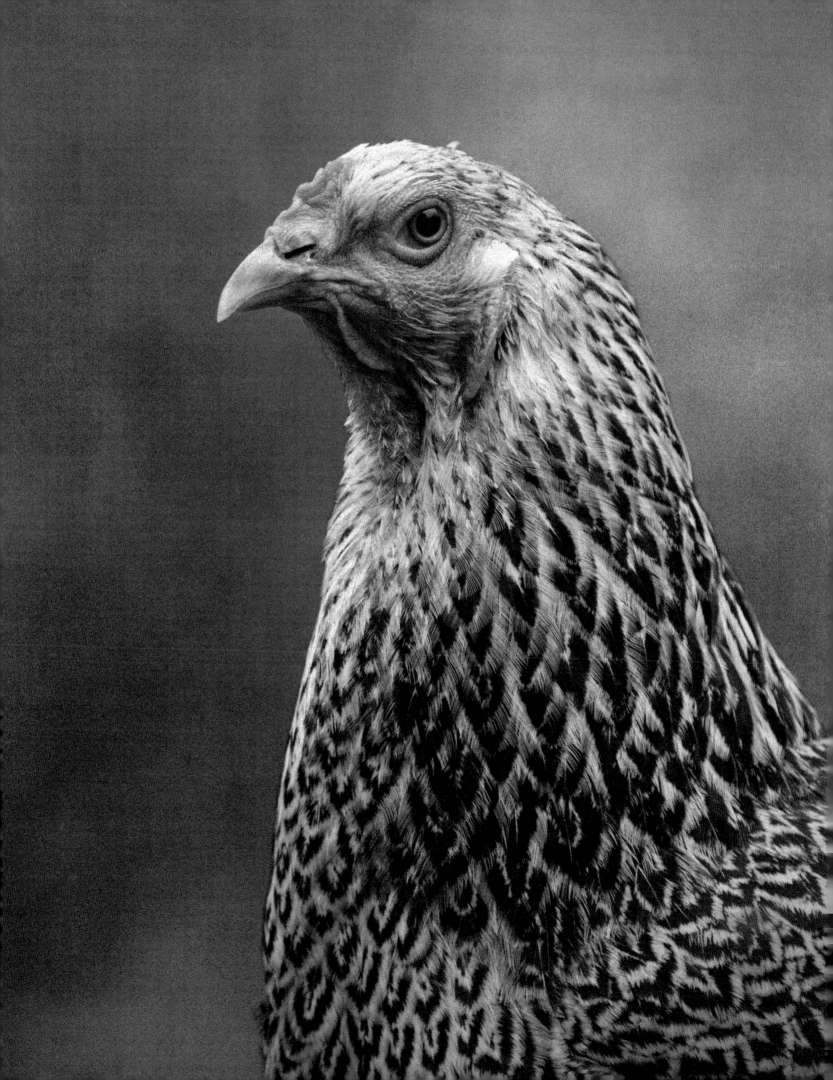

The modest Rose puts forth a thorn,

The humble Sheep a threat'ning horn:

While the Lilly white shall in Love delight,

Nor a thorn nor a threat stain her beauty bright.

—William Blake, "The Lilly" (1794)

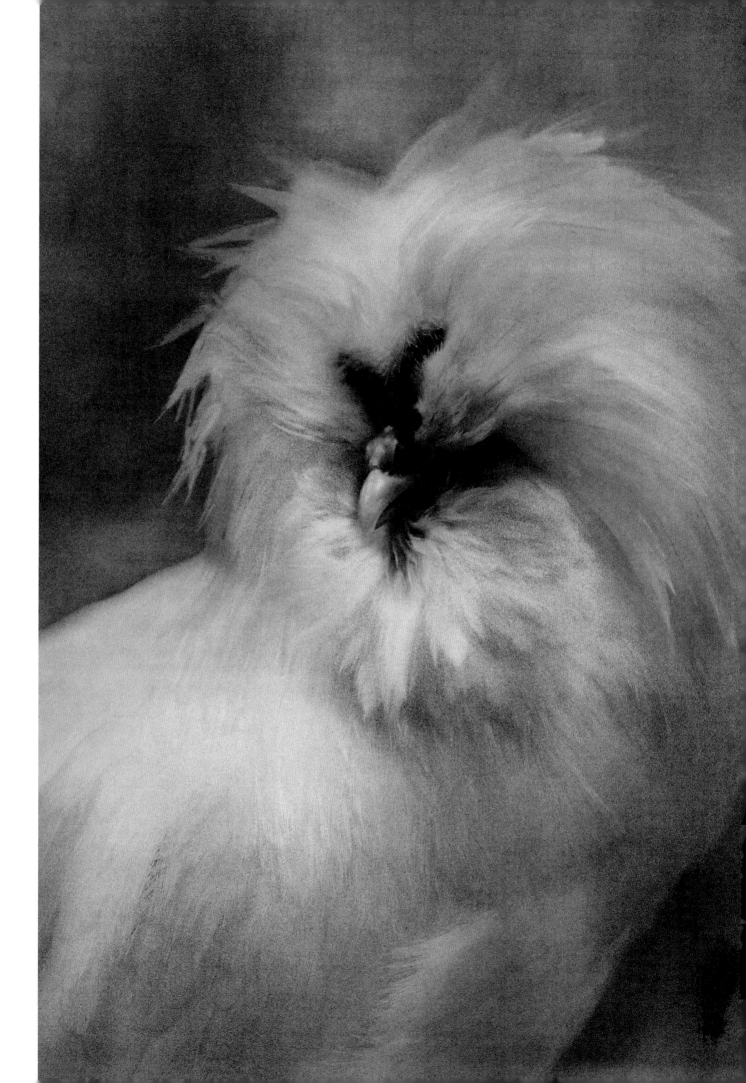

*W*hy, my dear, you must know, Mrs. Long says that Netherfield is taken by a young man of large fortune from the north of England. . . ."

"What is his name?"

"Bingley."

"Is he married or single?"

"Oh! Single, my dear, to be sure! A single man of large fortune; four or five thousand a year. What a fine thing for our girls!"

—Jane Austen, *Pride and Prejudice* (1813)

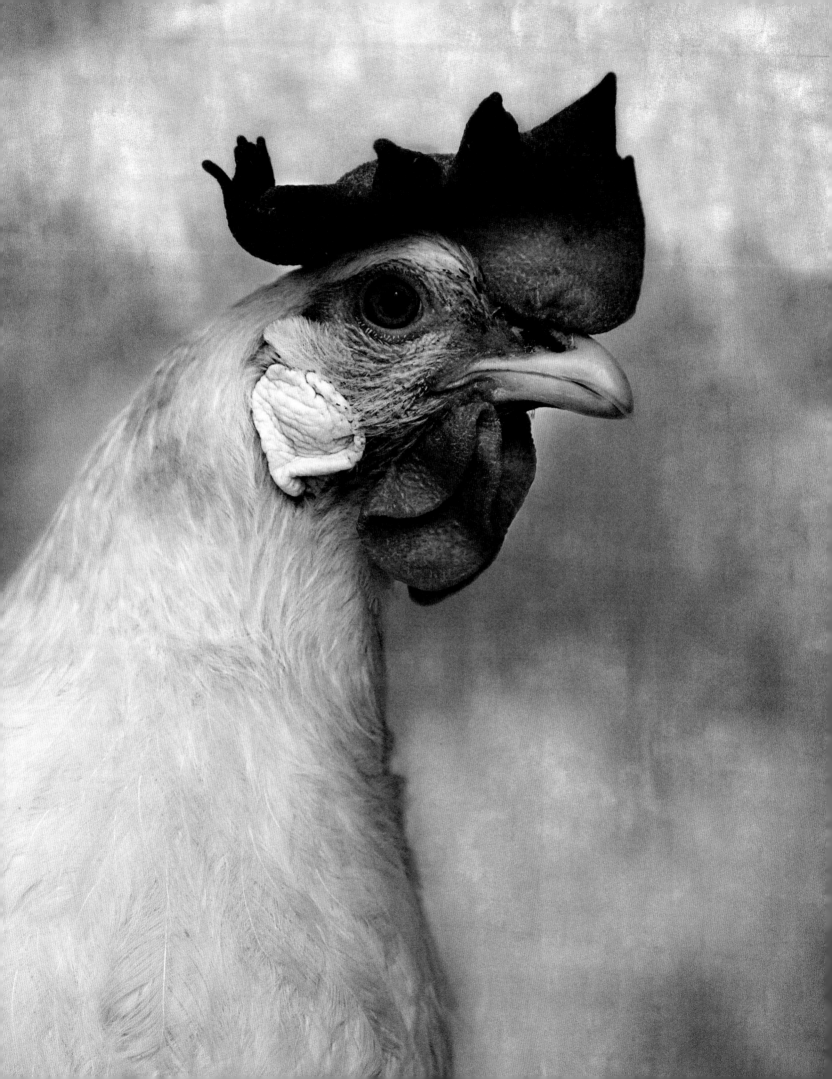

She walks in beauty, like the night

　　Of cloudless climes and starry skies;

　　And all that's best of dark and bright

　　Meet in her aspect and her eyes;

　　Thus mellowed to that tender light

　　Which heaven to gaudy day denies.

—Lord Byron, "She Walks in Beauty" (1815)

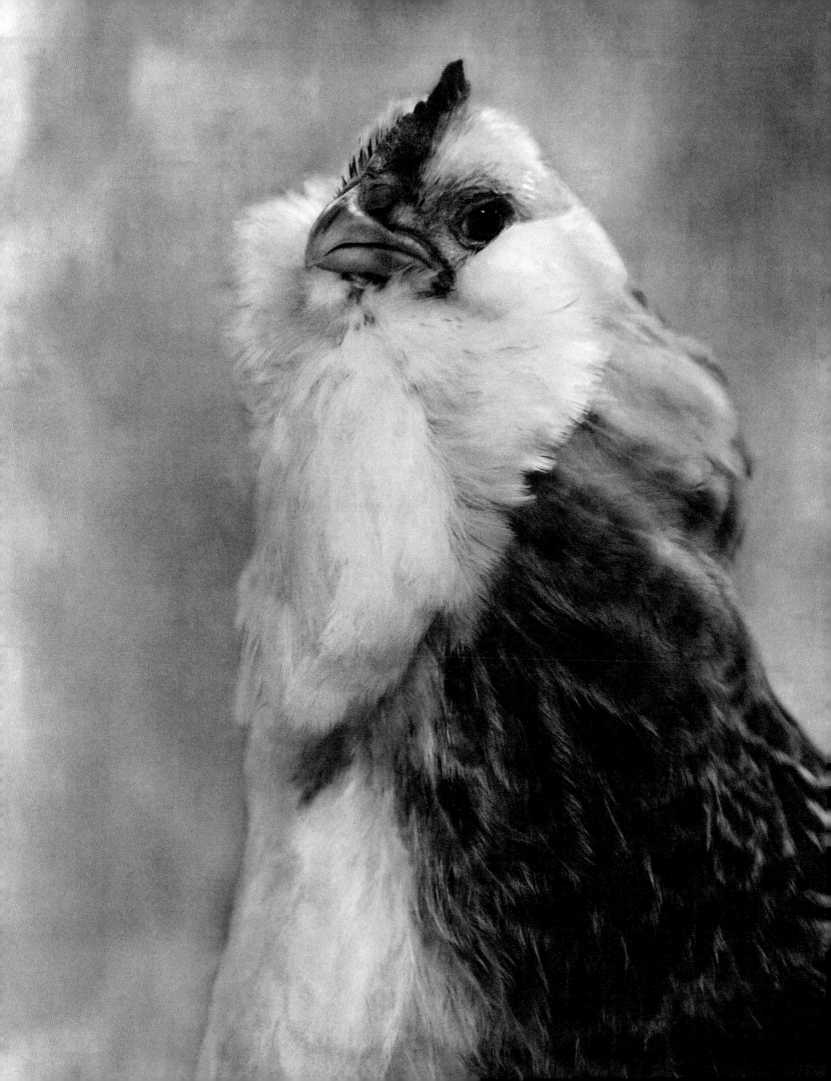

*M*adame de Rênal ... was a big, well-made woman, who had been the beauty of the country, to use the local expression. She had a certain air of simplicity and youthfulness in her deportment. This naive grace, with its innocence and its vivacity, might even have recalled to a Parisian some suggestion of the sweets he had left behind him.

—Stendhal, *The Red and the Black* (1830)

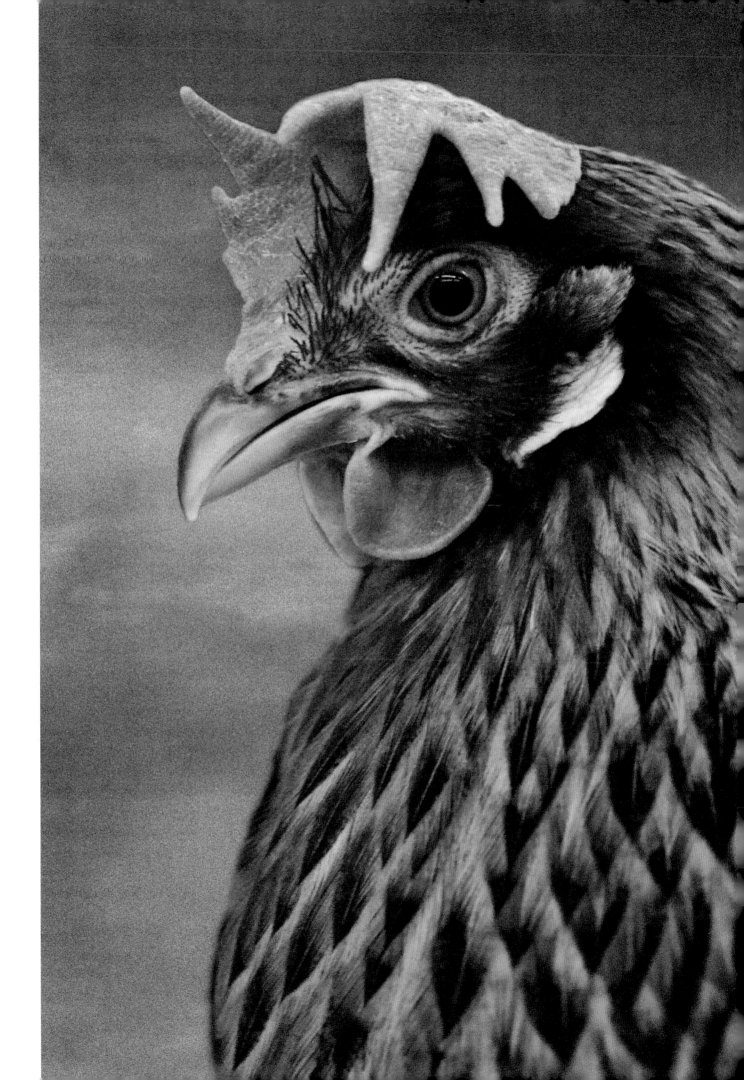

*F*inancially speaking, Monsieur Grandet was something between a tiger and a boa-constrictor. He could crouch and lie low, watch his prey a long while, spring upon it, open his jaws, swallow a mass of louis, and then rest tranquilly like a snake in process of digestion, impassible, methodical, and cold. No one saw him pass without a feeling of admiration mingled with respect and fear; had not every man in Saumur felt the rending of those polished steel claws?

—Honore de Balzac, *Eugenie Grandet* (1833)

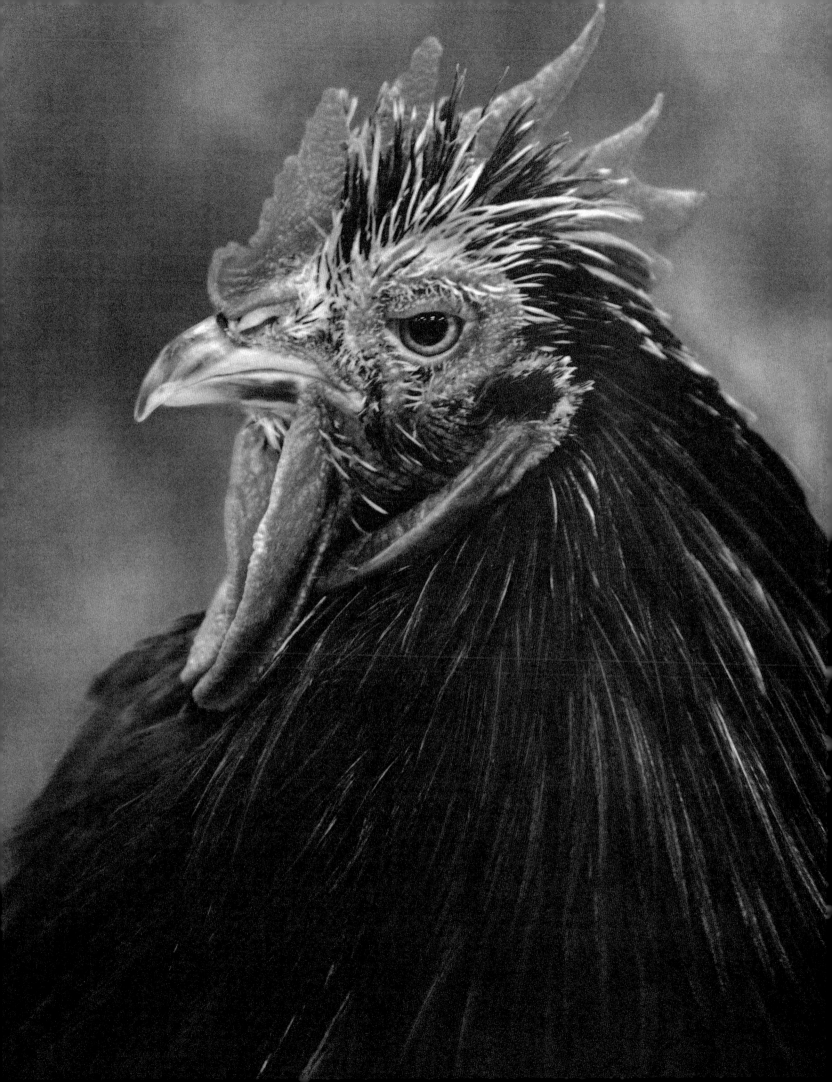

The Countess had no longer the slightest pretensions to beauty, but she still preserved the habits of her youth, dressed in strict accordance with the fashion of seventy years before, and made as long and as careful a toilette as she would have done sixty years previously.

—Alexander Pushkin,
"The Queen of Spades" (1834)

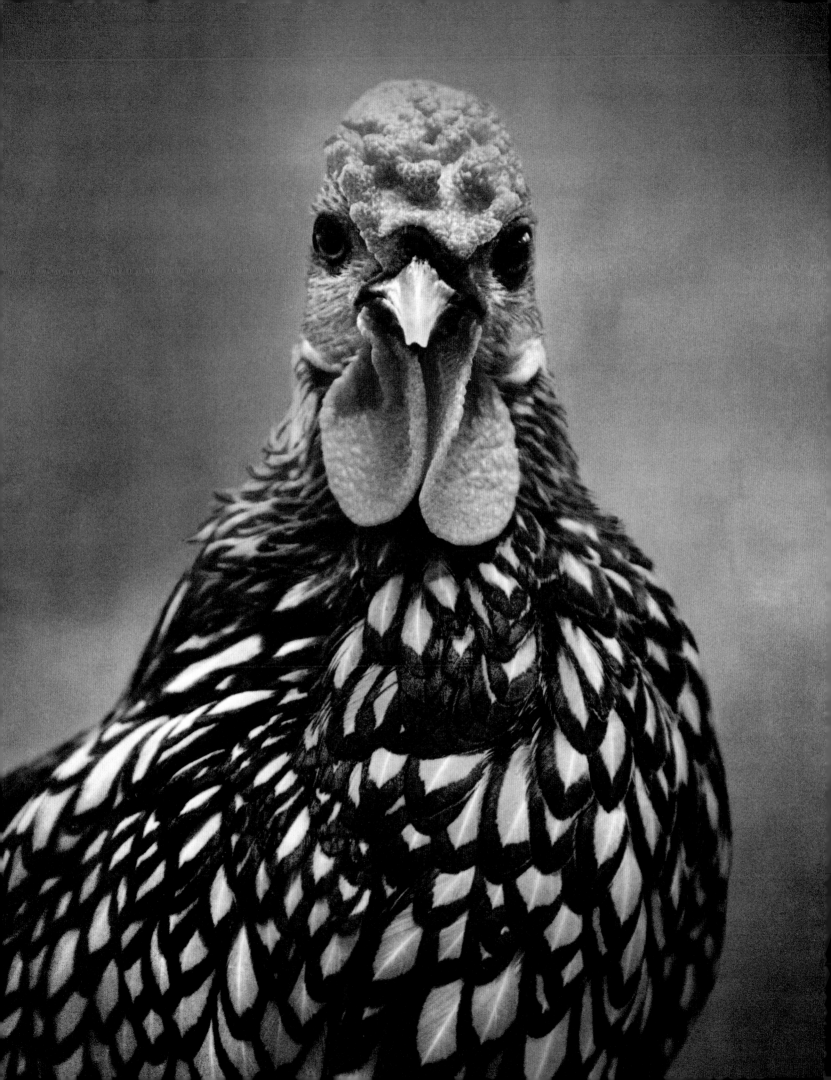

There is no Count of Monte Cristo," said Debray.

"I do not think so," added Château-Renaud, with the air of a man who knows the whole of the European nobility perfectly.

"Does anyone know anything of a Count of Monte Cristo?"

—Alexandre Dumas,
The Count of Monte Cristo (1845–46)

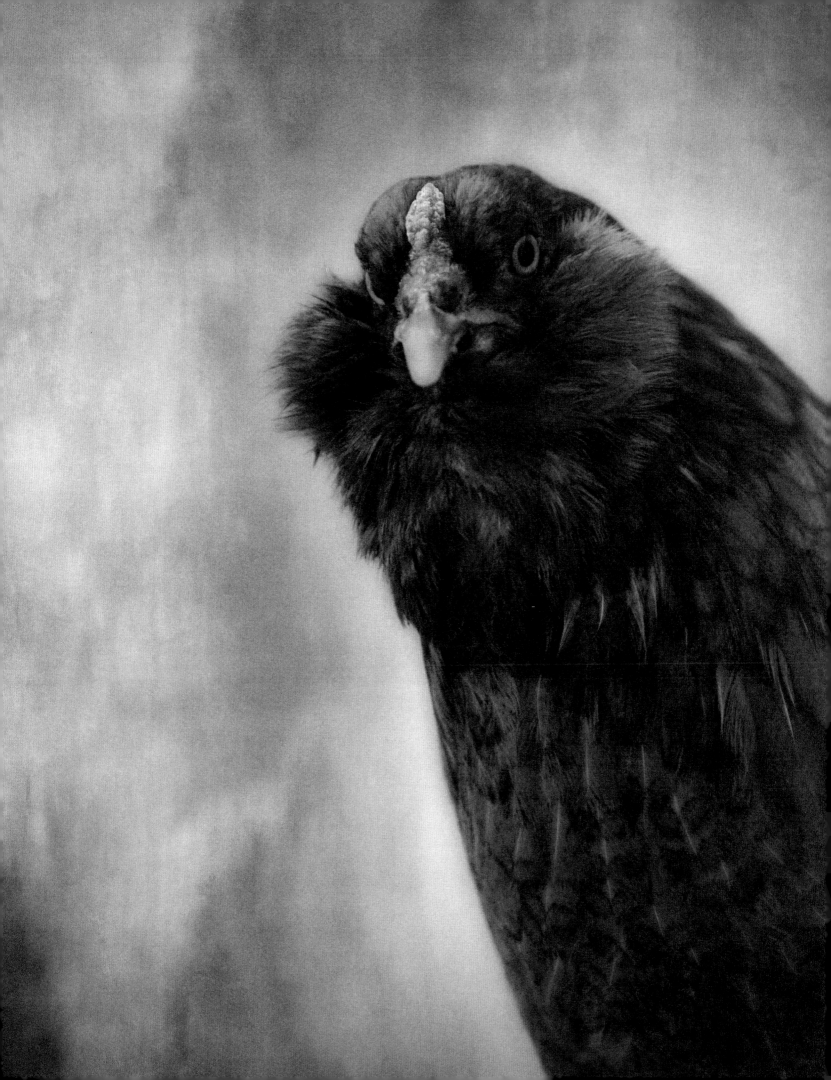

I assure you, a tiger or a venomous serpent could not rouse terror in me equal to that which he wakens.

—Emily Brontë, *Wuthering Heights* (1847)

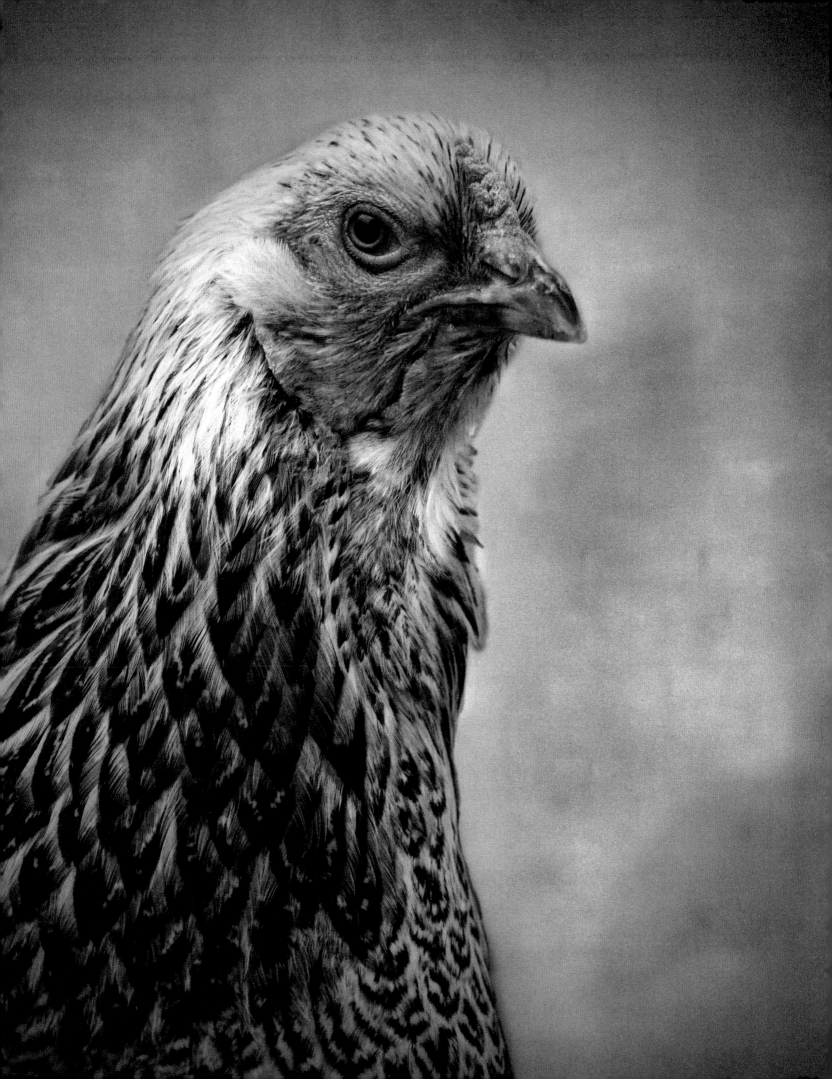

hat Osborne's a devil of a fellow. There was a judge's daughter at Demerara went almost mad about him; then there was that beautiful . . . Miss Pye, at St. Vincent's, you know; and since he's been home, they say he's a regular Don Giovanni, by Jove."

—William Makepeace Thackeray,
Vanity Fair (1848)

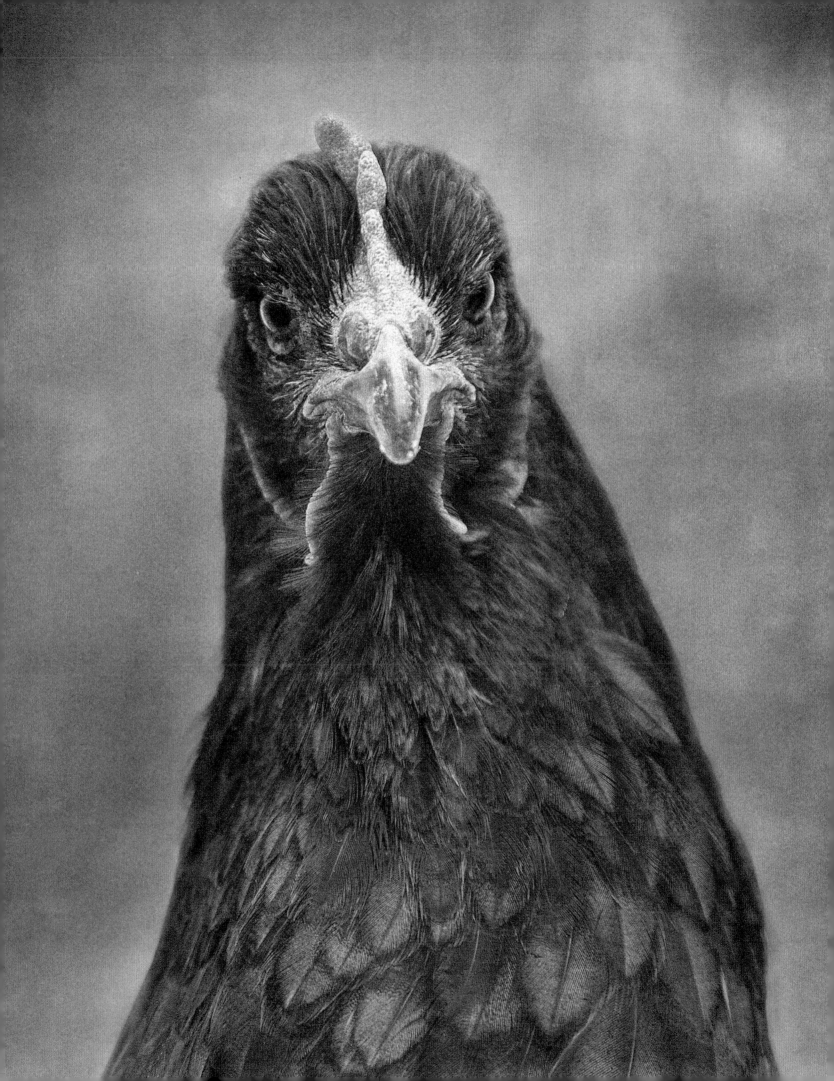

\mathcal{I}t seemed not so wild a dream—old as I was, and sombre as I was, and misshapen as I was—that the simple bliss, which is scattered far and wide, for all mankind to gather up, might yet be mine. And so, Hester, I drew thee into my heart, into its innermost chamber, and sought to warm thee by the warmth which thy presence made there!"

—Nathaniel Hawthorne,
The Scarlet Letter (1850)

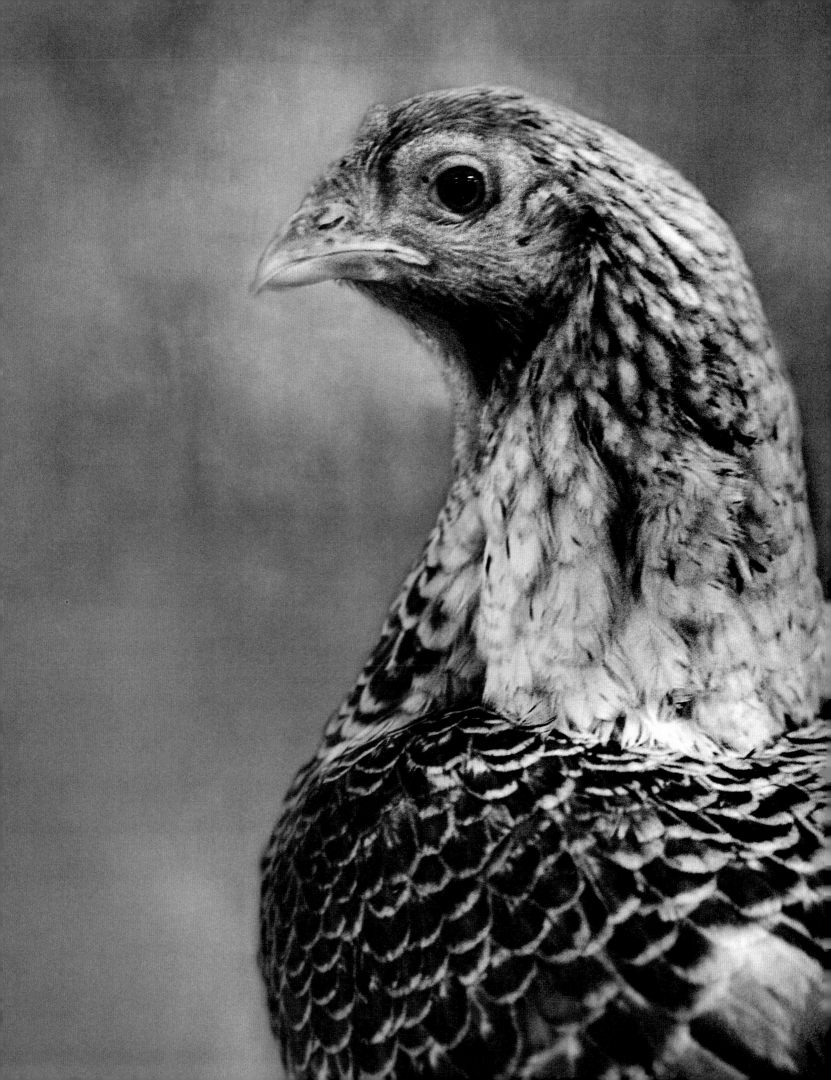

*A*gain, the dreaded Sunday comes round, and I file into the old pew first, like a guarded captive brought to a condemned service. Again, Miss Murdstone, in a black velvet gown, that looks as if it had been made out of a pall, follows close upon me. . . . Again, I listen to Miss Murdstone mumbling the responses, and emphasizing all the dread words with a cruel relish. Again, I see her dark eyes roll round the church when she says "miserable sinners," as if she were calling all the congregation names.

—Charles Dickens, *David Copperfield* (1850)

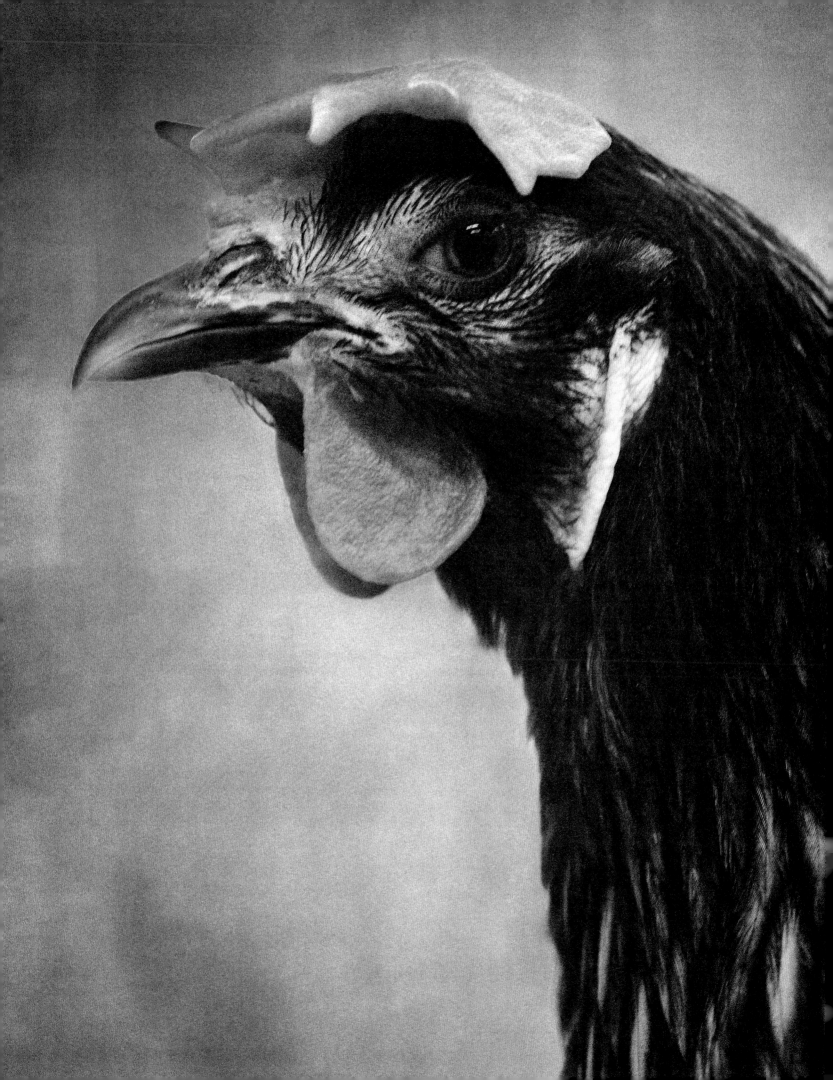

*L*andlord," I whispered, "that aint the harpooneer, is it?"

"Oh, no," said he, looking a sort of diabolically funny, "the harpooneer is a dark complexioned chap. He never eats dumplings, he don't—he eats nothing but steaks, and he likes 'em rare."

"The devil he does," says I. "Where is that harpooneer? Is he here?"

"He'll be here afore long," was the answer.

—Herman Melville,
Moby-Dick; or, The Whale (1851)

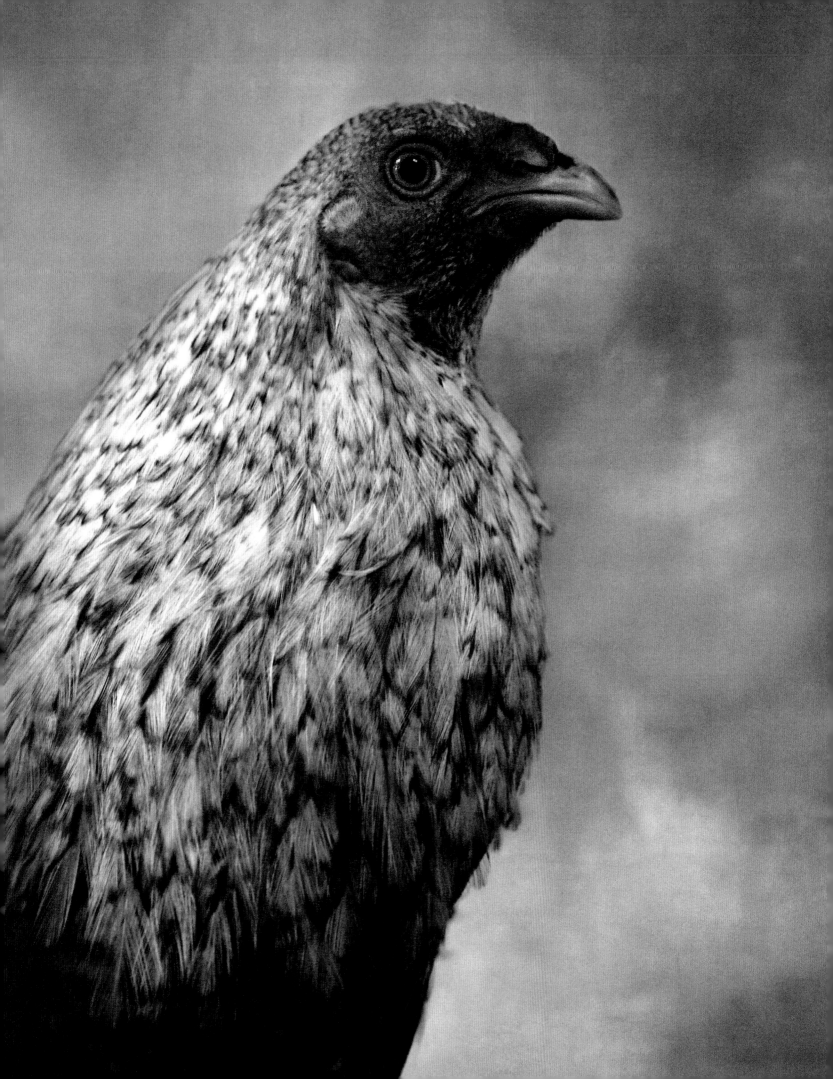

Everything immediately surrounding her—boring countryside, inane petty bourgeois, the mediocrity of daily life—seemed to her the exception rather than the rule. She had been caught in it all by some accident: out beyond, there stretched as far as the eye could see the immense territory of rapture and passions. In her longing she made no difference between the pleasures of luxury and the joys of the heart, between elegant living and sensitive feeling. Didn't love, like Indian plants, require rich soils, special temperatures?

—Gustave Flaubert, *Madame Bovary* (1857)

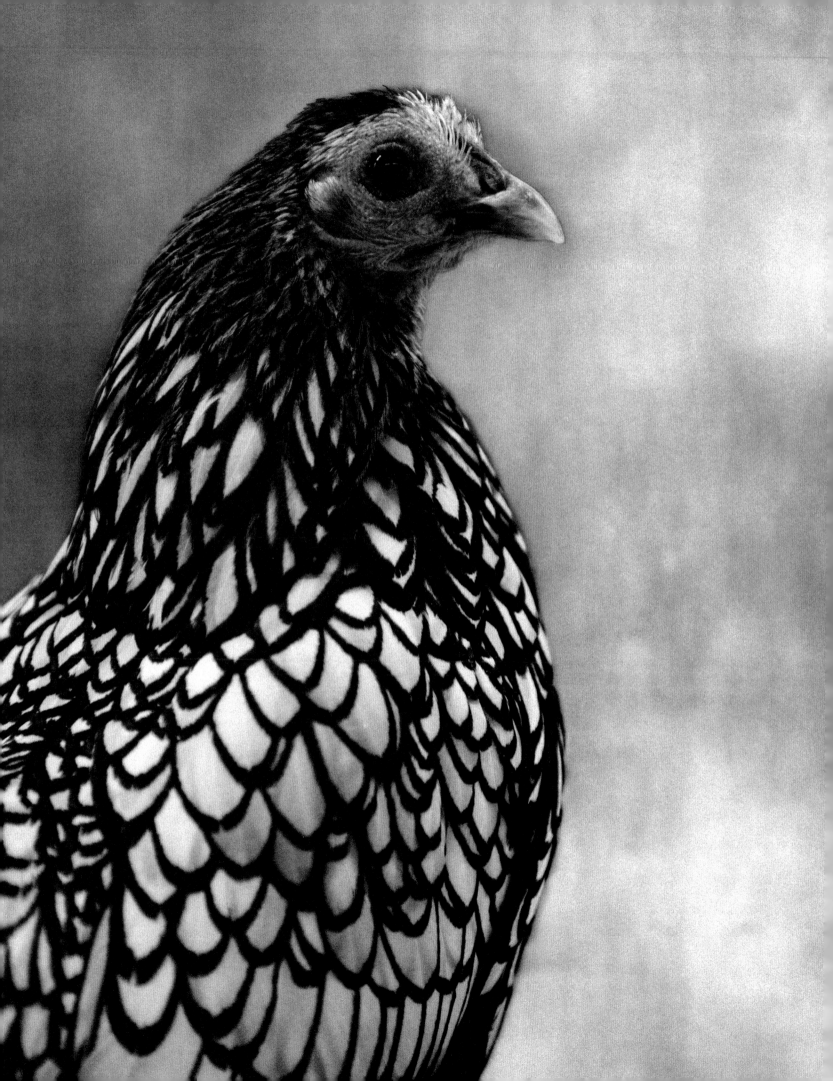

*P*ip, dear old chap, life is made of ever so many part-
ings welded together."

—Charles Dickens, *Great Expectations* (1861)

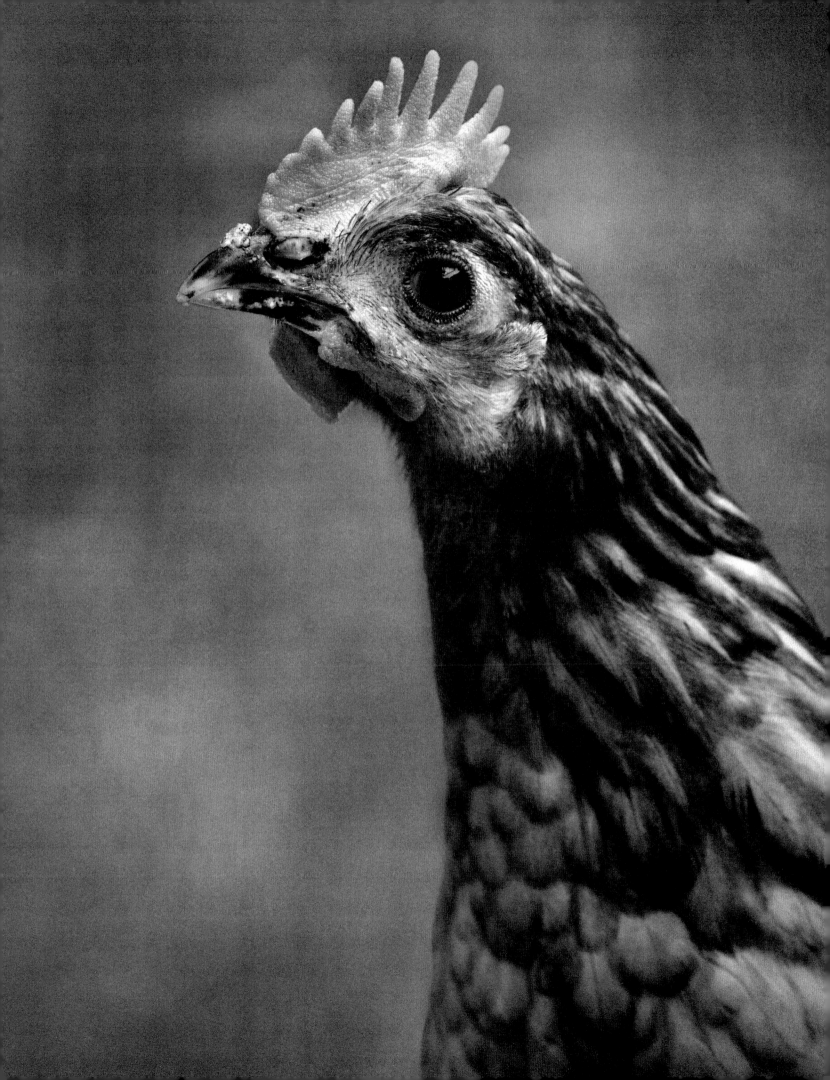

*D*id a voice whisper in his ear that he had just passed through the decisive hour of his destiny, that there was no longer a middle course for him, that if, thereafter, he should not be the best of men, he would be the worst . . . ?

—Victor Hugo, *Les Misérables* (1862)

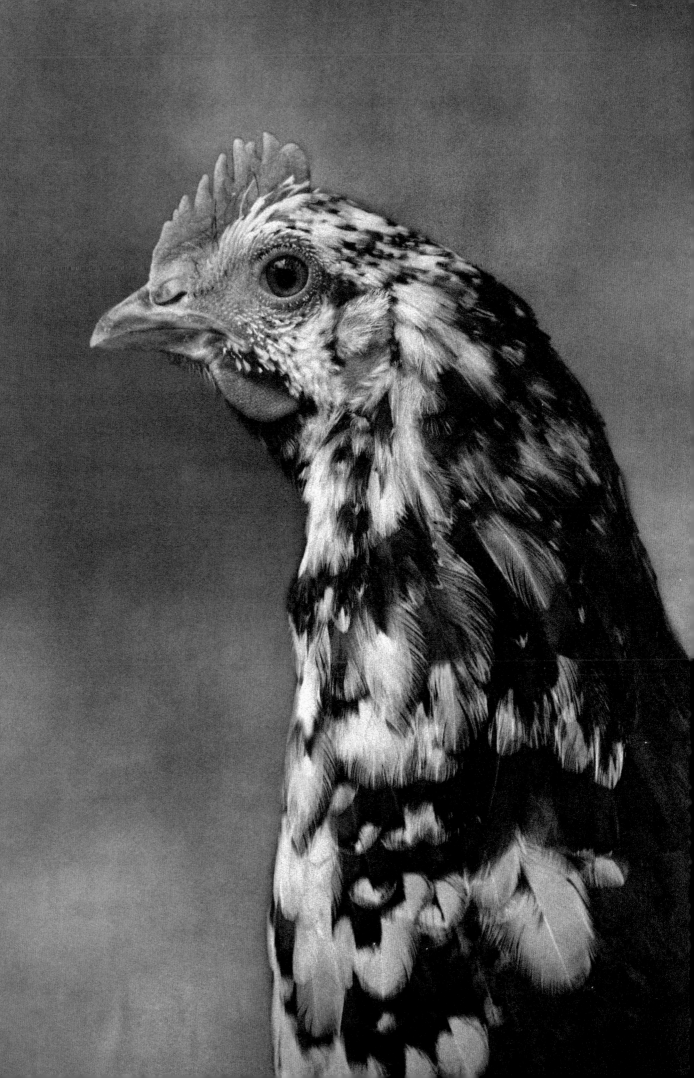

*A*n old maid, that's what I'm to be. A literary spinster, with a pen for a spouse, a family of stories for children, and twenty years hence a morsel of fame, perhaps, when, like poor Johnson, I'm old and can't enjoy it, solitary, and can't share it, independent, and don't need it."

—Louisa May Alcott, *Little Women* (1869)

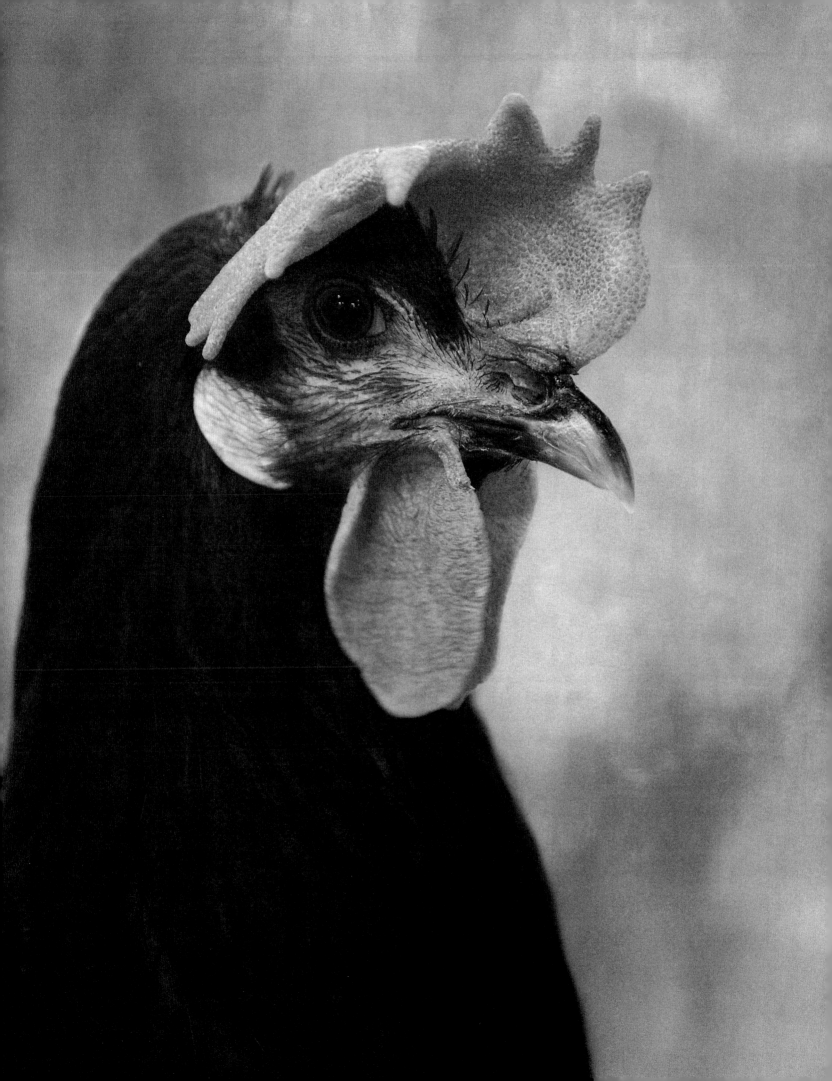

*E*veryone brightened at the sight of this pretty young woman, so soon to become a mother, so full of life and health, and carrying her burden so lightly. Old men and dull dispirited young ones who looked at her, after being in her company and talking to her a little while, felt as if they too were becoming, like her, full of life and health.

—Leo Tolstoy, *War and Peace* (1868–69)

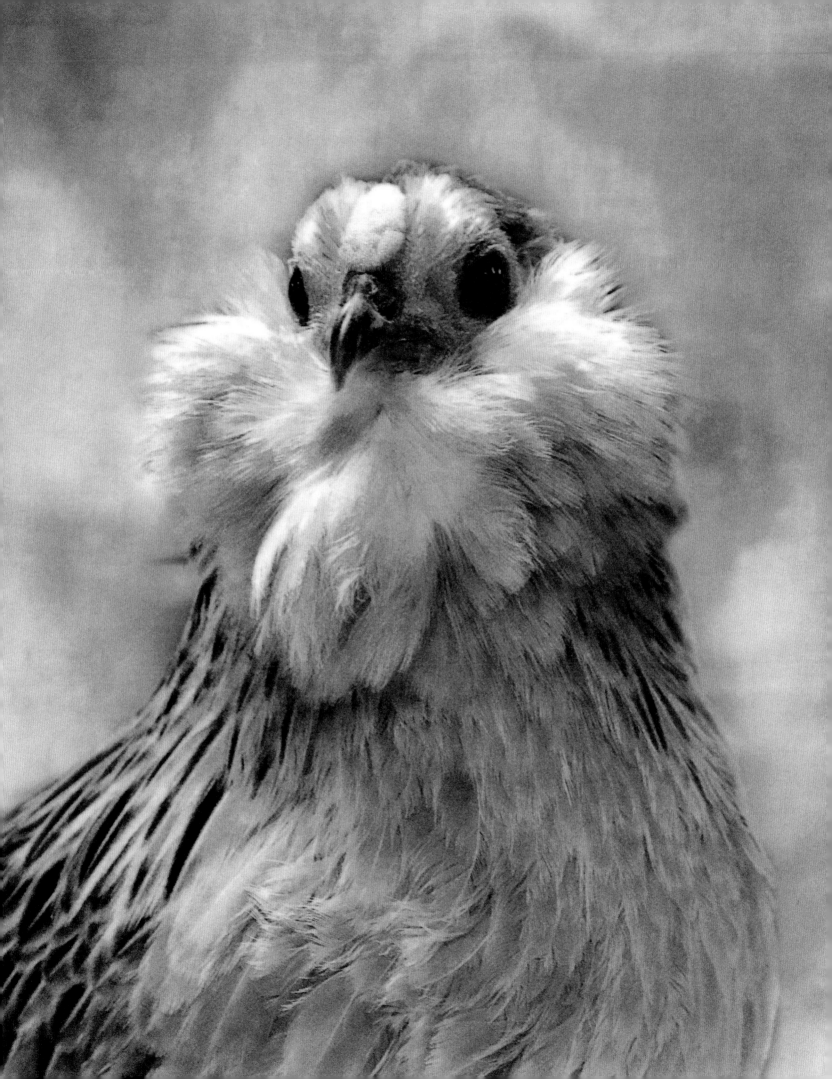

I wonder what your vocation will turn out to be: perhaps you will be a poet?"

"That depends. To be a poet is to have a soul so quick to discern that no shade of quality escapes it, and so quick to feel, that discernment is but a hand playing with finely ordered variety on the chords of emotion—a soul in which knowledge passes instantaneously into feeling, and feeling flashes back as a new organ of knowledge."

—George Eliot, *Middlemarch* (1871)

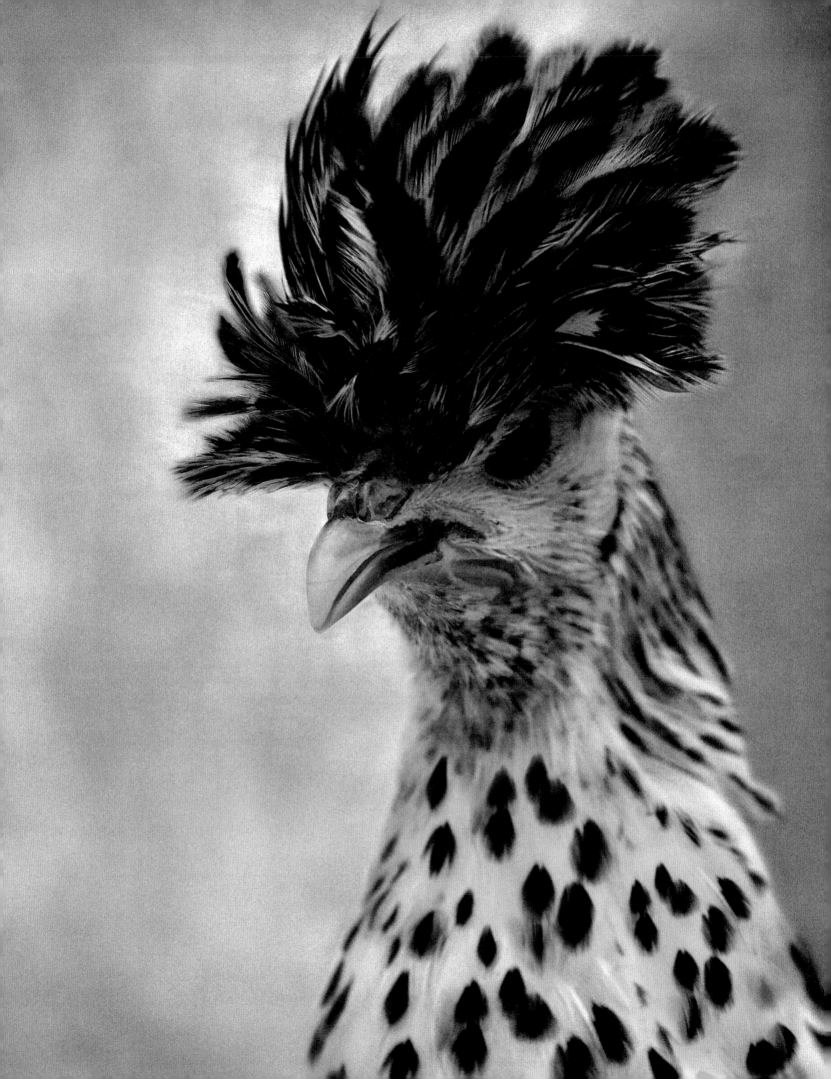

His aunt Polly stood surprised a moment, and then broke into a gentle laugh.

"Hang the boy, can't I never learn anything? Ain't he played me tricks enough like that for me to be looking out for him by this time? But old fools is the biggest fools there is. Can't learn an old dog new tricks, as the saying is. But my goodness, he never plays them alike, two days, and how is a body to know what's coming?"

—Mark Twain,
The Adventures of Tom Sawyer (1876)

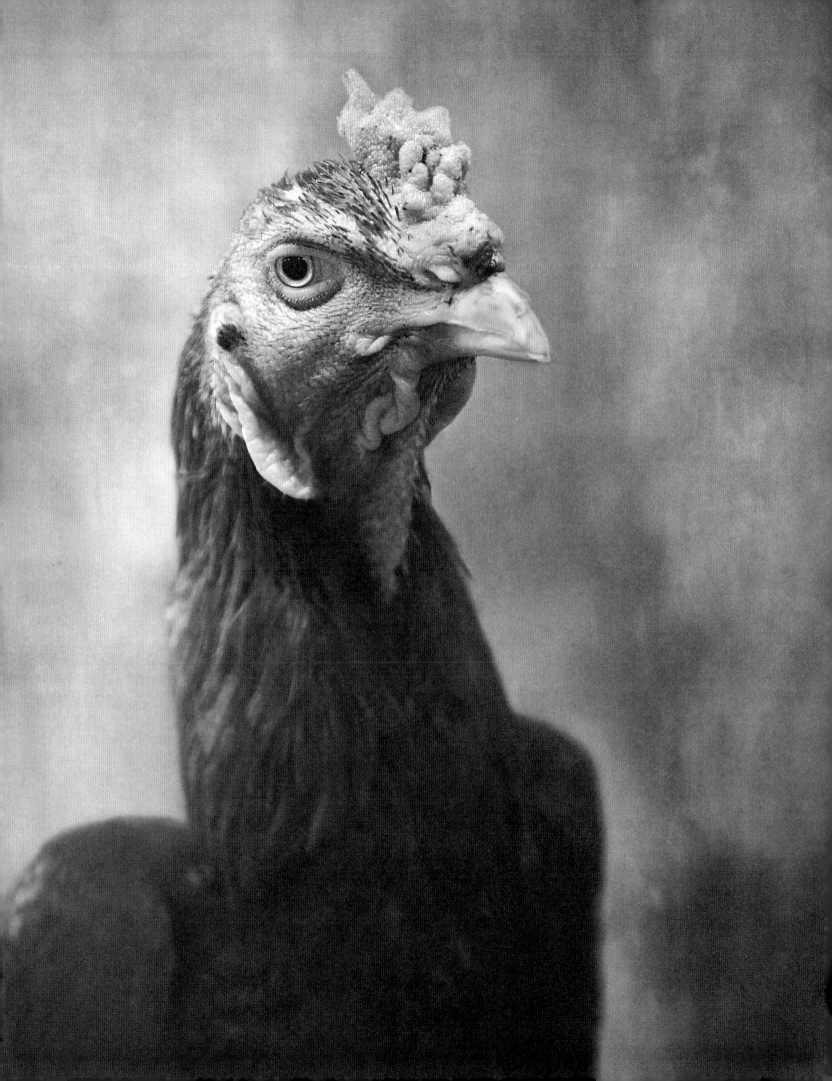

ave you ever felt, have you ever dreamt of falling down a precipice into a pit? That's just how I'm falling, but not in a dream. And I'm not afraid, and don't you be afraid. At least, I am afraid, but I enjoy it. It's not enjoyment though, but ecstasy. Damn it all, whatever it is! A strong spirit, a weak spirit, a womanish spirit—whatever it is! Let us praise nature: you see what sunshine, how clear the sky is, the leaves are all green, it's still summer; four o'clock in the afternoon and the stillness!"

—Fyodor Dostoyevsky,
The Brothers Karamazov (1881)

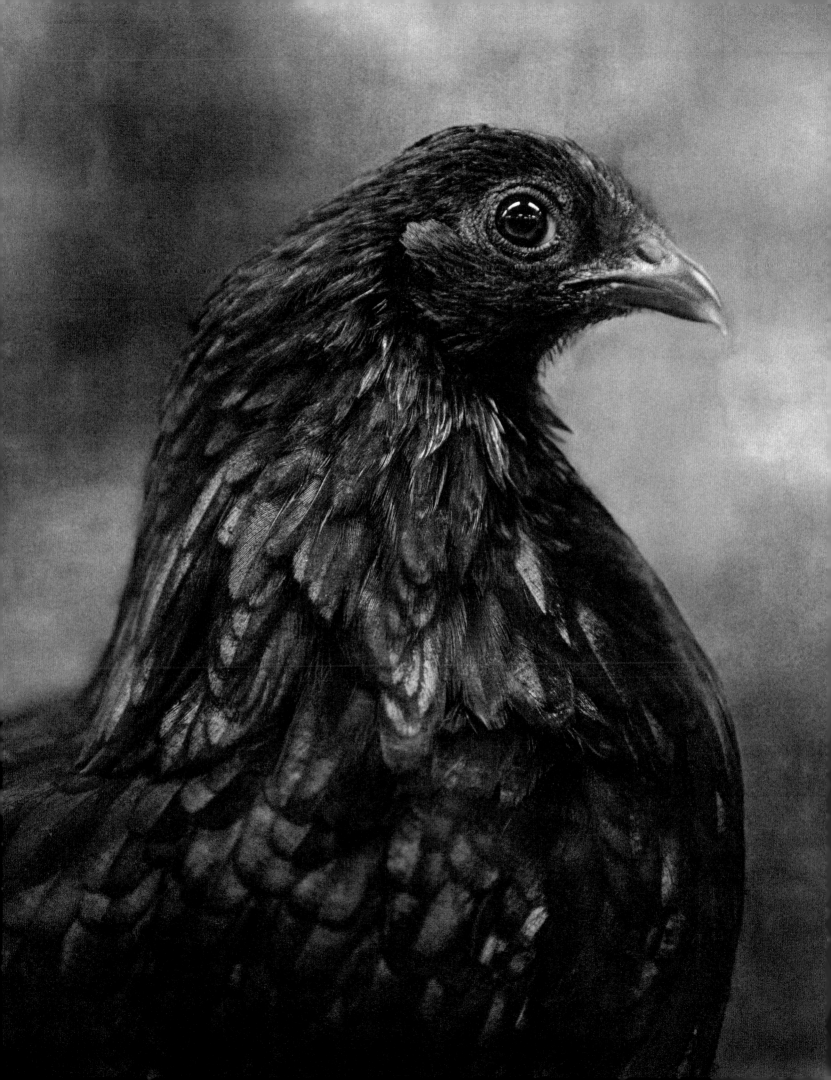

I don't pretend to know what people are meant for," said Madame Merle. "I only know what I can do with them."

—Henry James, *The Portrait of a Lady* (1881)

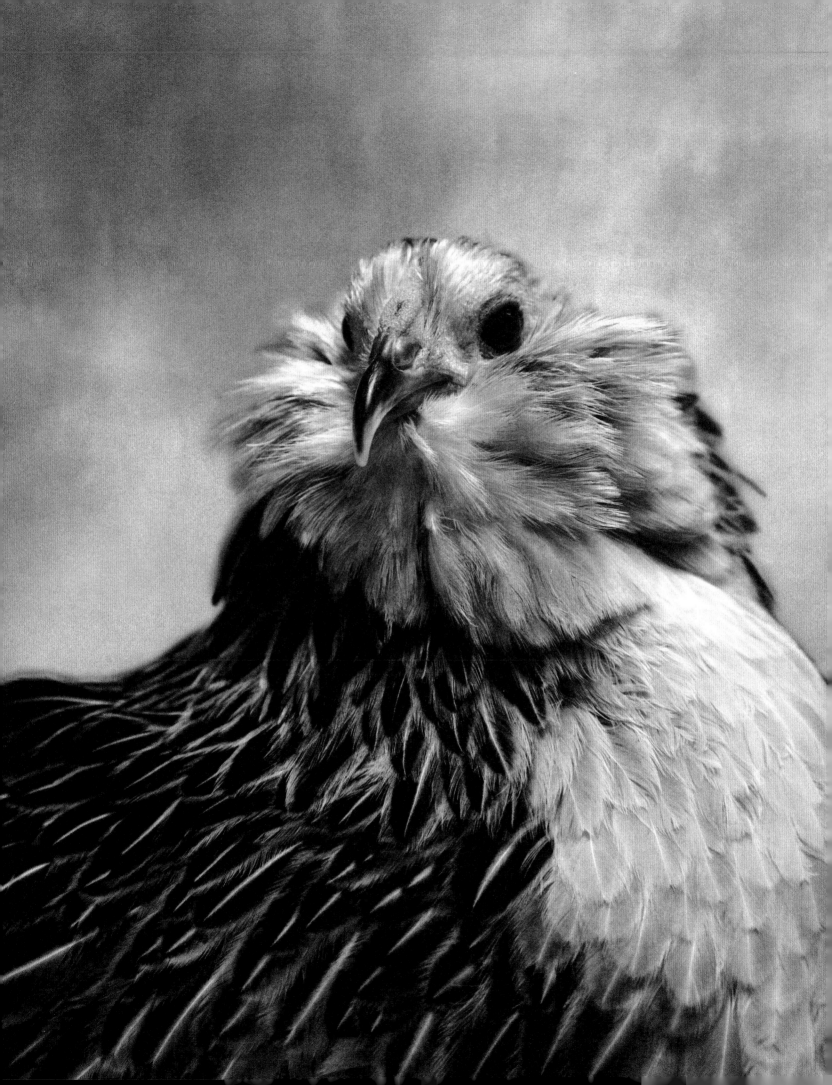

*W*hy, who makes much of a miracle?

As to me I know of nothing else but miracles. . . .

—Walt Whitman, "Miracles" (1881)

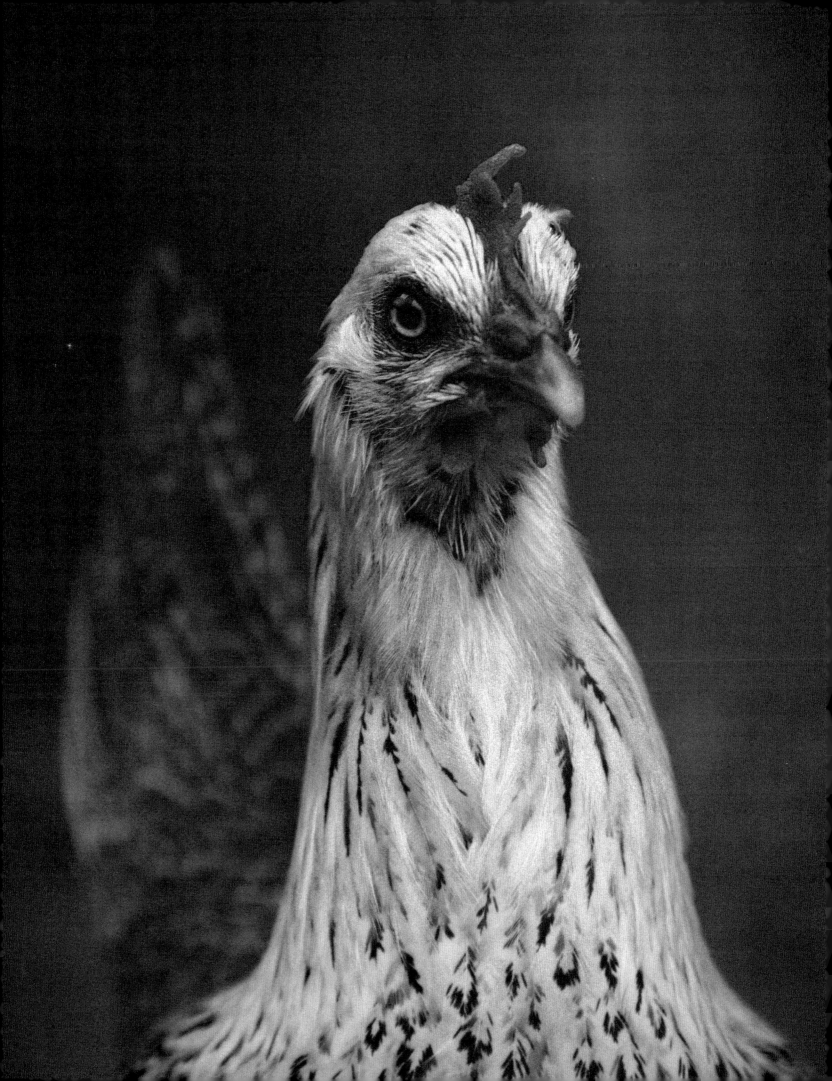

I was far less afraid of the captain . . . than anybody else who knew him. There were nights when he took a deal more rum and water than his head would carry; and then he would sometimes sit and sing his wicked, old, wild sea-songs, minding nobody; but sometimes he would call for glasses round and force all the trembling company to listen to his stories or bear a chorus to his singing.

—Robert Louis Stevenson,
Treasure Island (1883)

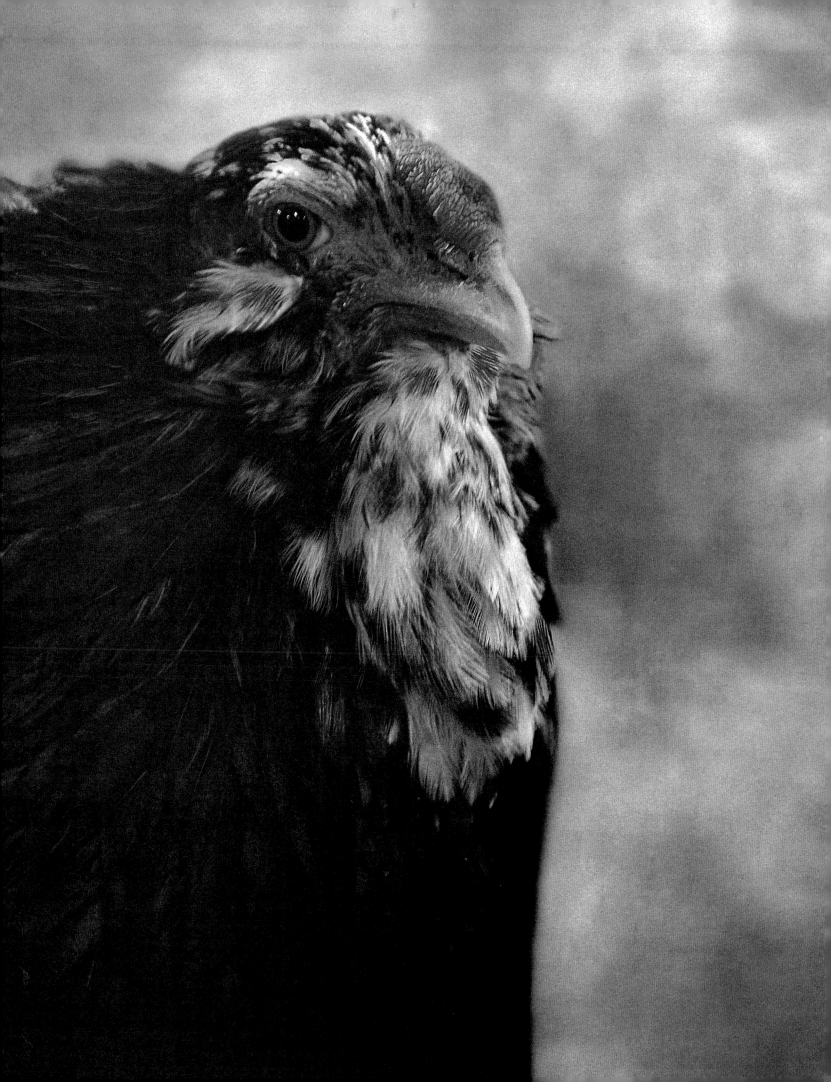

*B*rother to a Prince and fellow to a beggar if he be found worthy."

The Law, as quoted, lays down a fair conduct of life, and one not easy to follow. I have been fellow to a beggar again and again under circumstances which prevented either of us finding out whether the other was worthy. I have still to be brother to a Prince, though I once came near to kinship with what might have been a veritable King.

—Rudyard Kipling,
"The Man Who Would Be King" (1888)

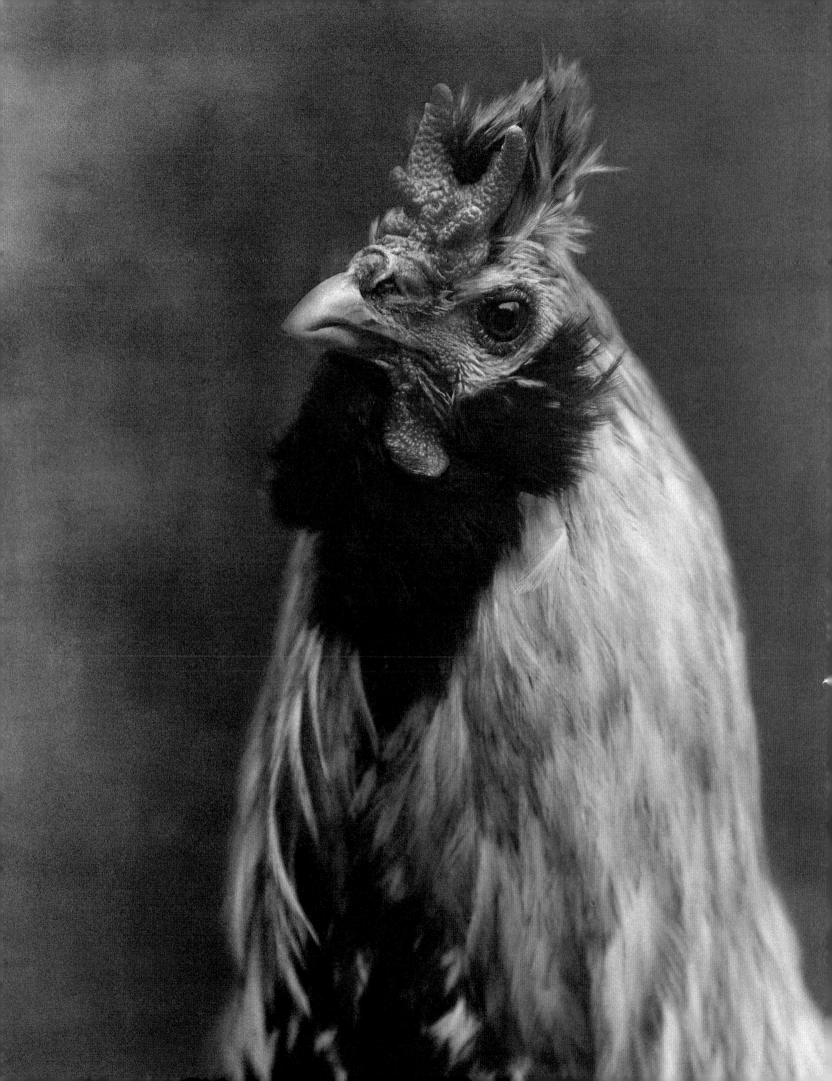

*L*et your boat of life be light, packed with only what you need—a homely home and simple pleasures, one or two friends, worth the name, someone to love and someone to love you, a cat, a dog, and a pipe or two, enough to eat and enough to wear, and a little more than enough to drink; for thirst is a dangerous thing.

—Jerome K. Jerome, *Three Men in a Boat* (1889)

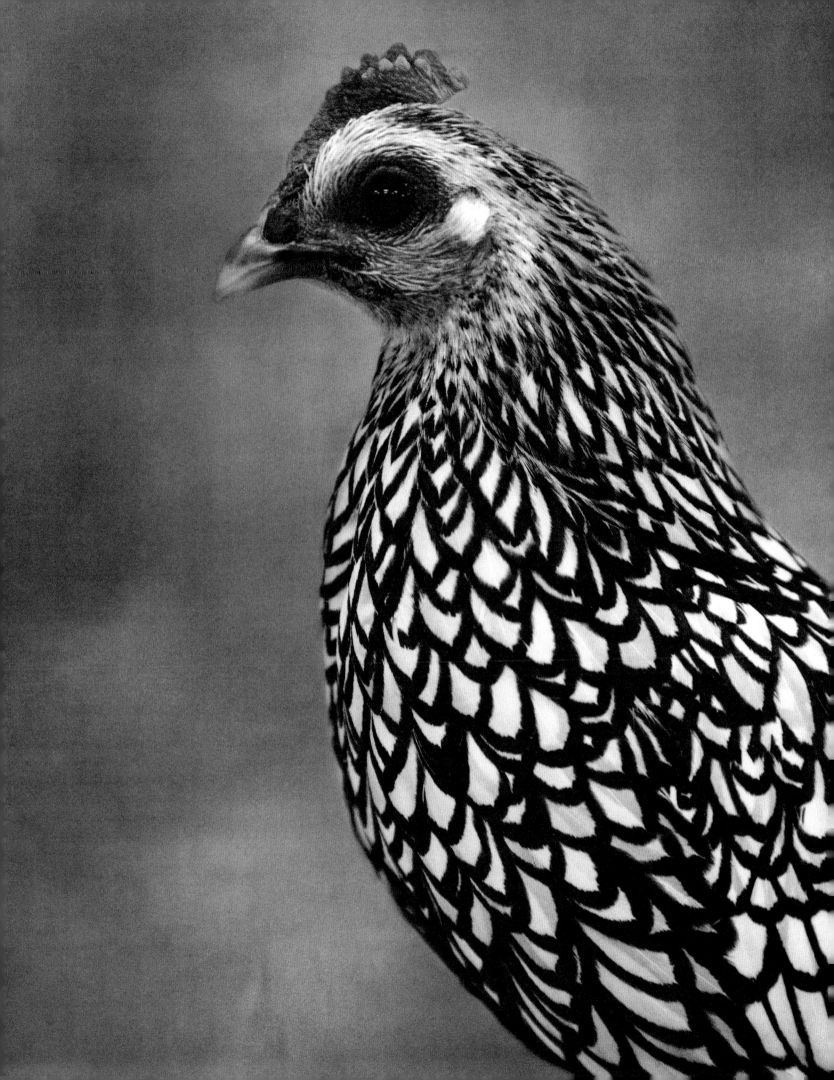

The butterfly's assumption-gown,
In chrysoprase apartments hung,
This afternoon put on.

How condescending to descend,
And be of buttercups the friend
In a New England town!

—Emily Dickinson (published 1890)

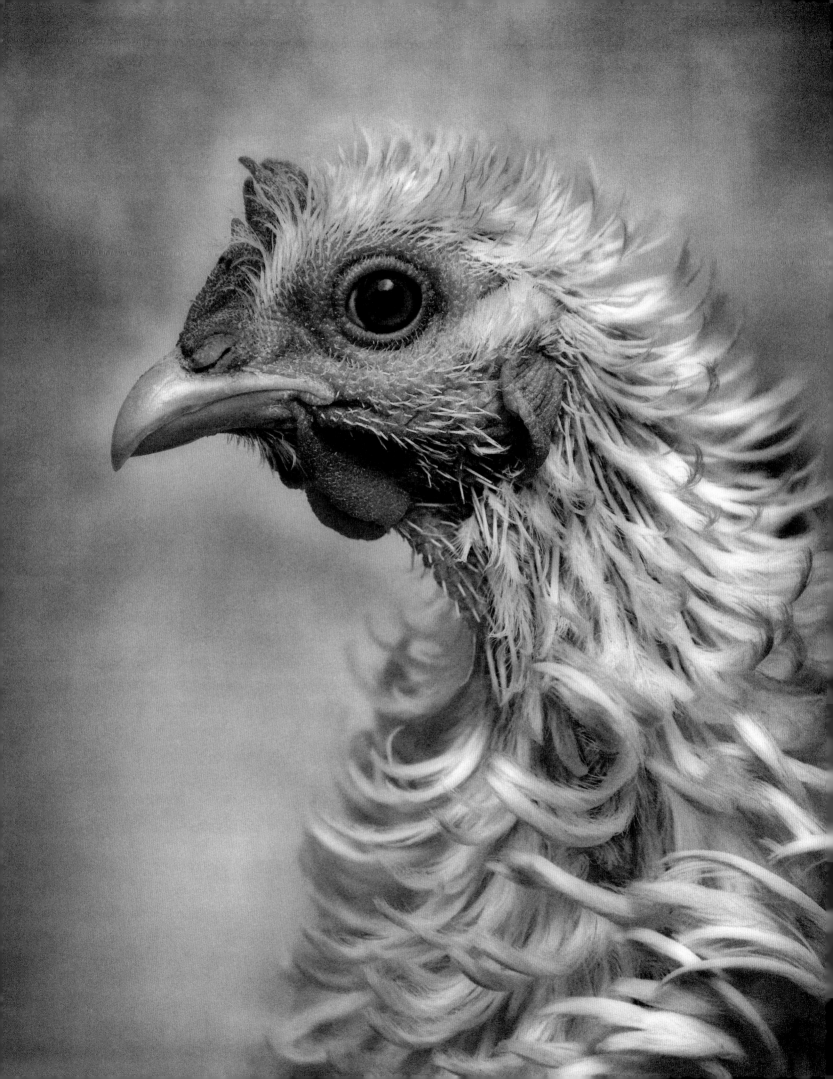

What a woman—oh, what a woman!" cried the King of Bohemia, when we had all three read this epistle. "Did I not tell you how quick and resolute she was? Would she not have made an admirable queen? Is it not a pity that she was not on my level?"

"From what I have seen of the lady, she seems, indeed, to be on a very different level to your Majesty," said Holmes coldly.

—Sir Arthur Conan Doyle,
 "A Scandal in Bohemia" (1891)

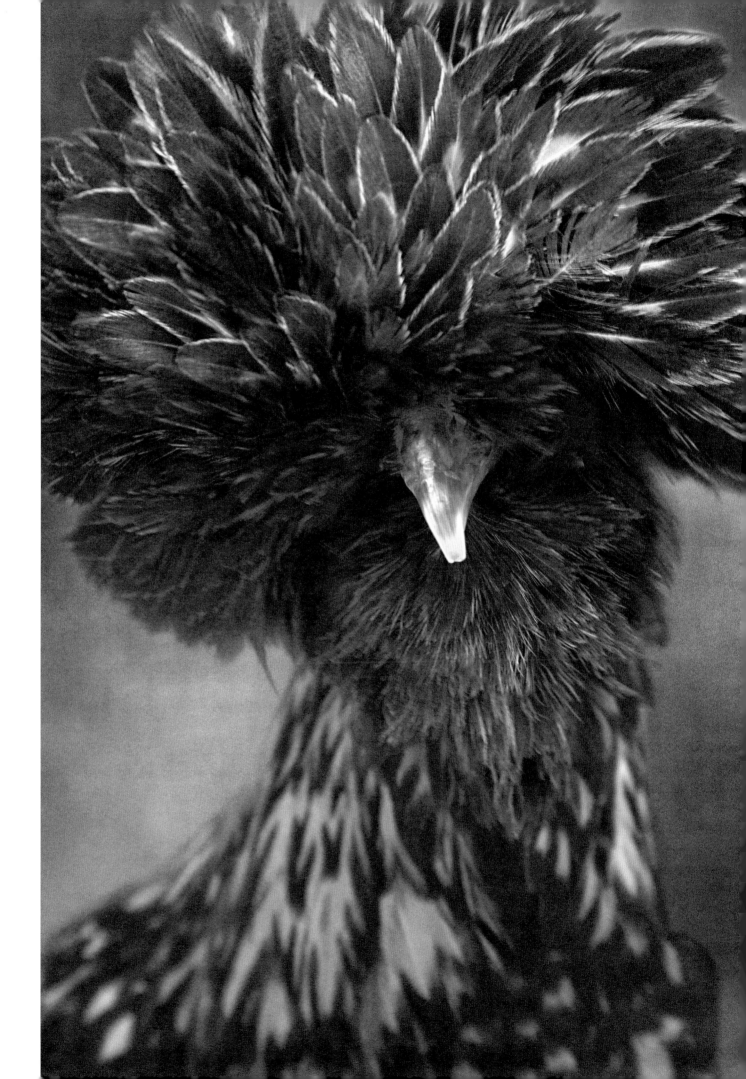

JACK *I* am sick to death of cleverness. Everybody is clever nowadays. You can't go anywhere without meeting clever people. The thing has become an absolute public nuisance. I wish to goodness we had a few fools left.

ALGERNON We have.

JACK I should extremely like to meet them. What do they talk about?

ALGERNON The fools? Oh! about the clever people, of course.

JACK What fools!

—Oscar Wilde,
 The Importance of Being Earnest (1895)

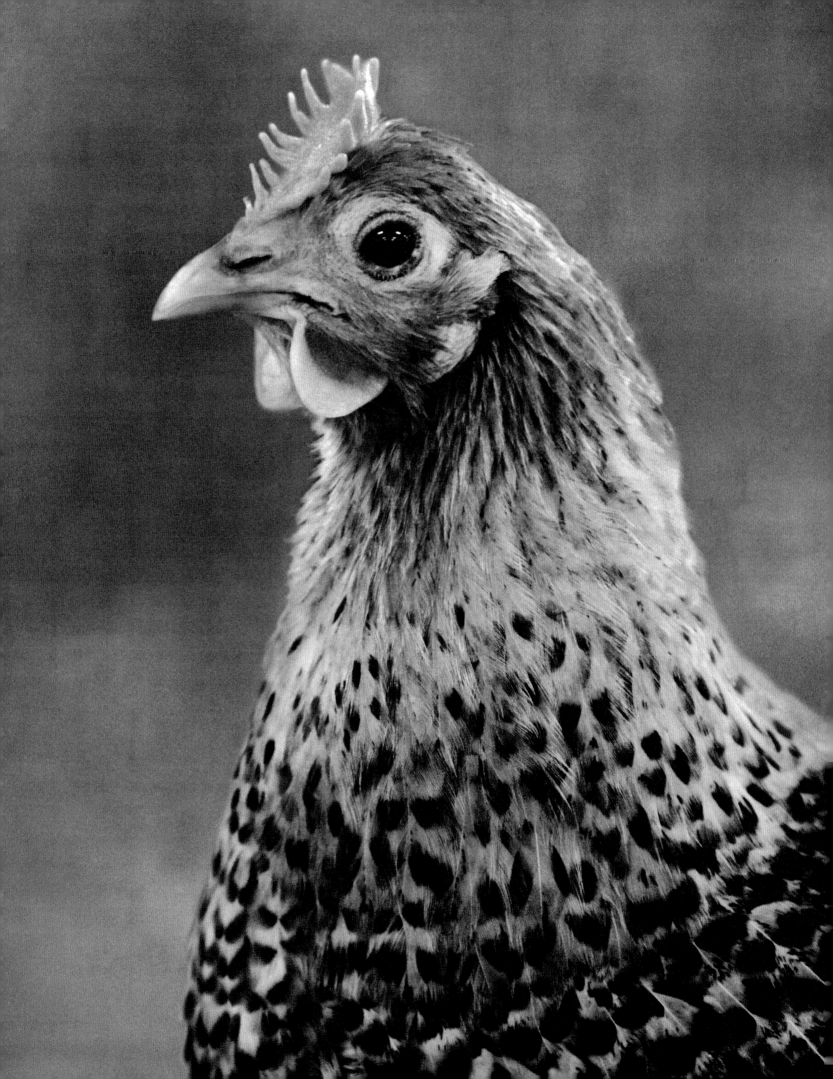

I myself am of an old family, and to live in a new house would kill me. A house cannot be made habitable in a day; and, after all, how few days go to make up a century. I rejoice also that there is a chapel of old times. We Transylvanian nobles love not to think that our bones may lie amongst the common dead."

—Bram Stoker, *Dracula* (1897)

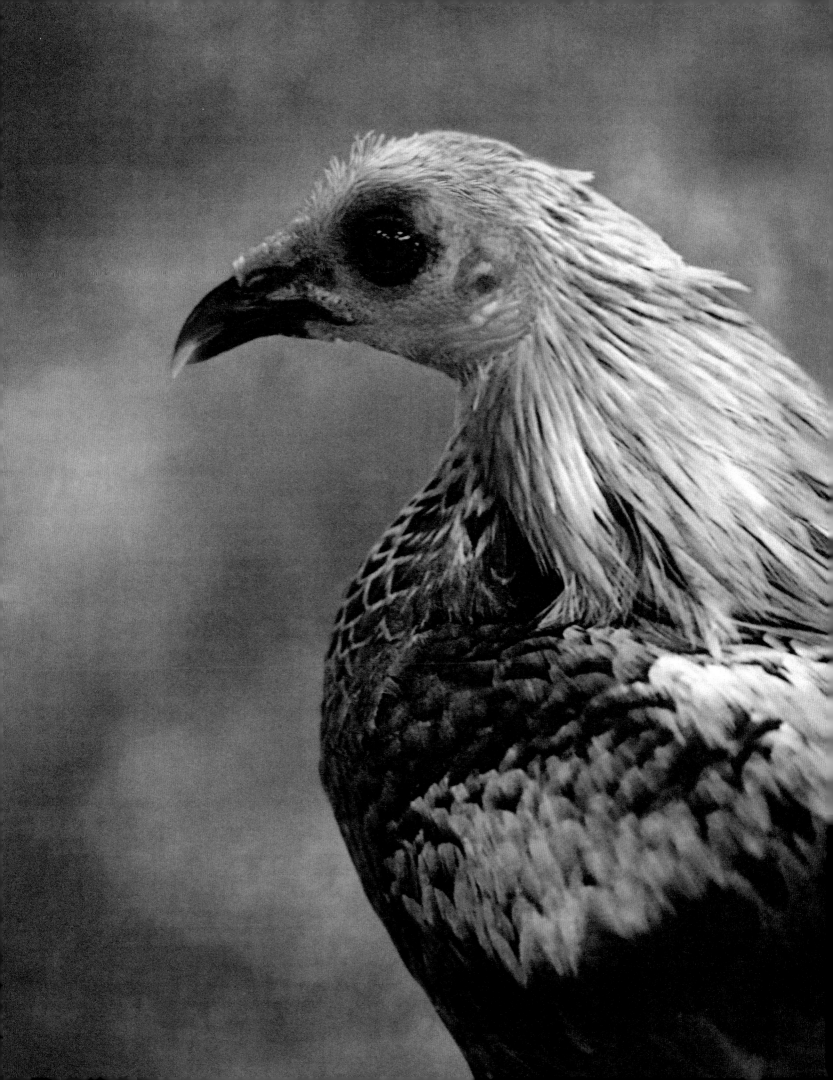

*N*o matter how dreary and gray our homes are, we people of flesh and blood would rather live there than in any other country, be it ever so beautiful. There is no place like home."

—L. Frank Baum,
The Wonderful Wizard of Oz (1900)

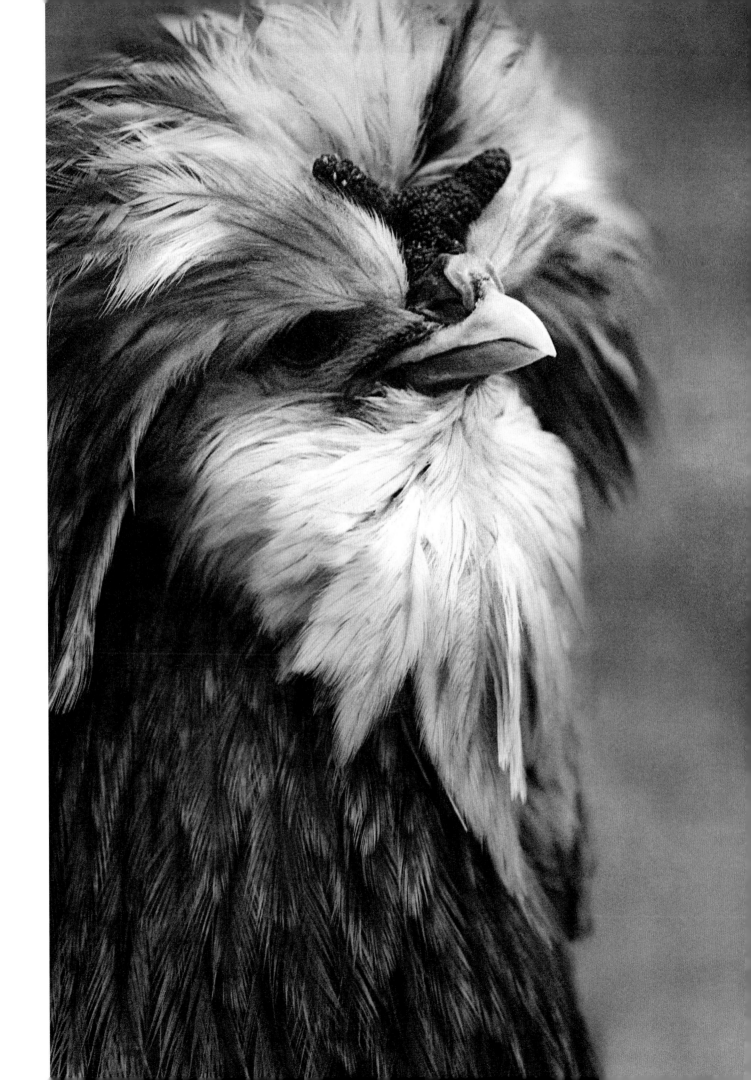

Only the maidens question not

The bridges that lead to Dream;

Their luminous smiles are like strands of pearls

On a silver vase agleam.

The maidens' doors of Life lead out

Where the song of the poet soars,

And out beyond to the great world—

To the world beyond the doors.

—Rainer Maria Rilke, "Maidens I" (1902)

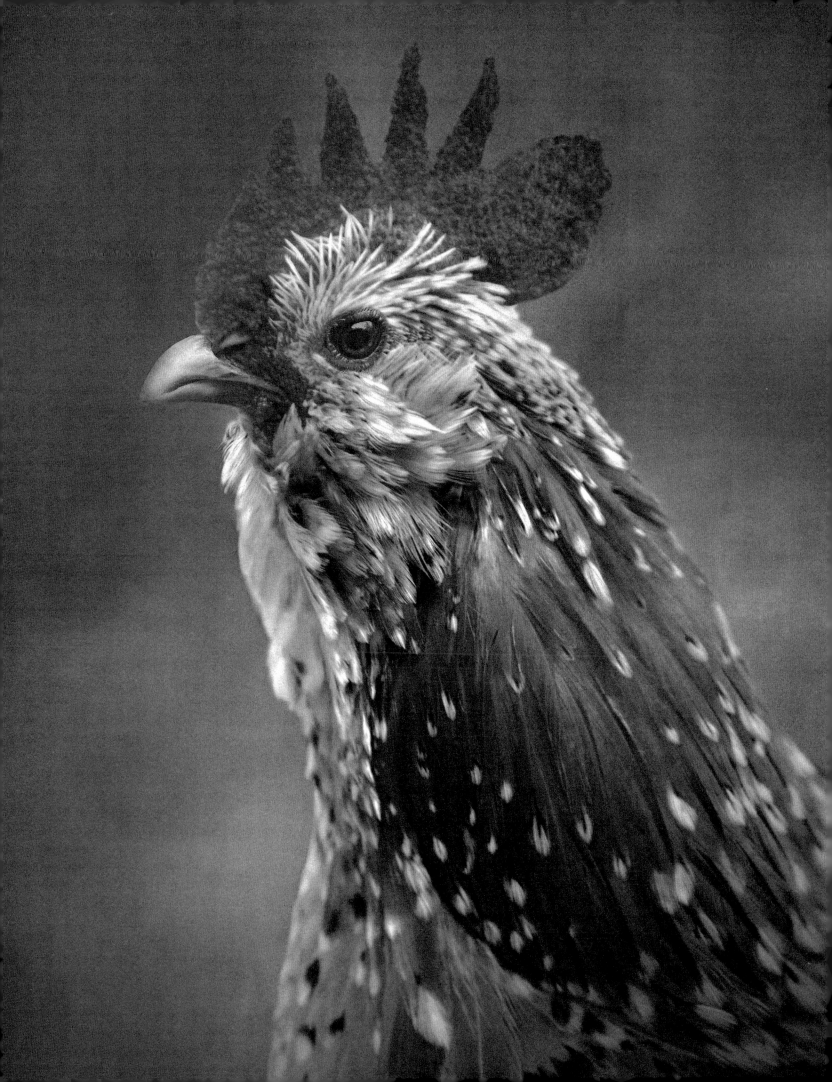

With the aurora borealis flaming coldly overhead, or the stars leaping in the frost dance, and the land numb and frozen under its pall of snow, this song of the huskies might have been the defiance of life, only it was pitched in minor key, with long-drawn wailings and half-sobs, and was more the pleading of life, the articulate travail of existence. . . . And that he should be stirred by it marked the completeness with which he harked back through the ages of fire and roof to the raw beginnings of life in the howling ages.

—Jack London, *The Call of the Wild* (1903)

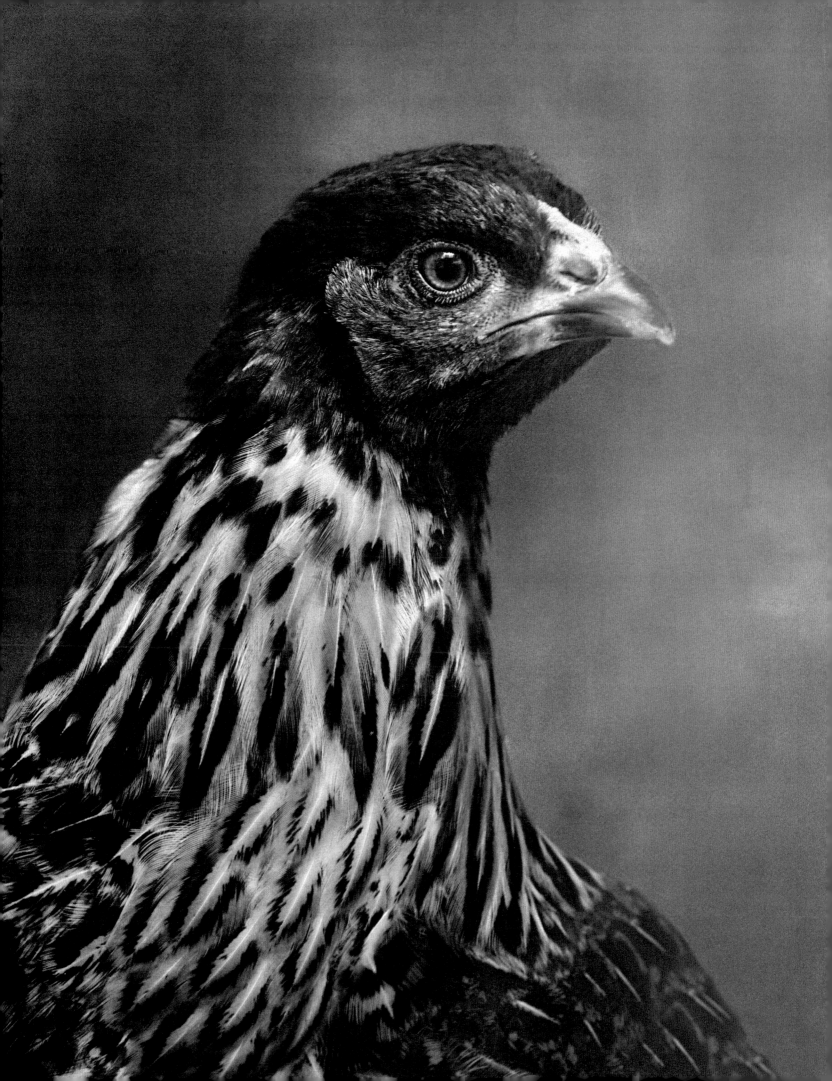

*W*hy were most big things unladylike? . . . It was not that ladies were inferior to men; it was that they were different. Their mission was to inspire others to achievement rather than to achieve themselves. Indirectly, by means of tact and a spotless name, a lady could accomplish much. But if she rushed into the fray herself she would be first censured, then despised, and finally ignored. Poems had been written to illustrate this point.

—E. M. Forster, *A Room with a View* (1908)

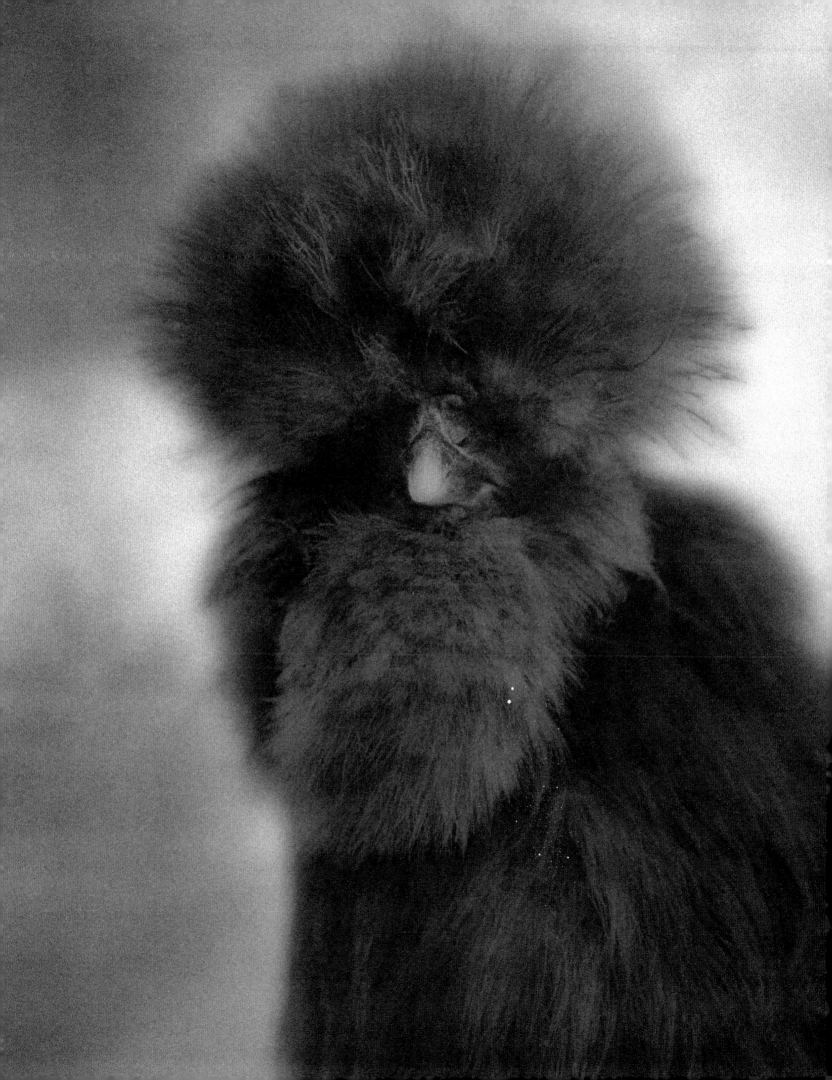

The dear old days when I could fly!"

"Why can't you fly now, mother?"

"Because I am grown up, dearest. When people grow up they forget the way."

"Why do they forget the way?"

"Because they are no longer gay and innocent and heartless. It is only the gay and innocent and heartless who can fly."

—J. M. Barrie, *Peter Pan* (1911)

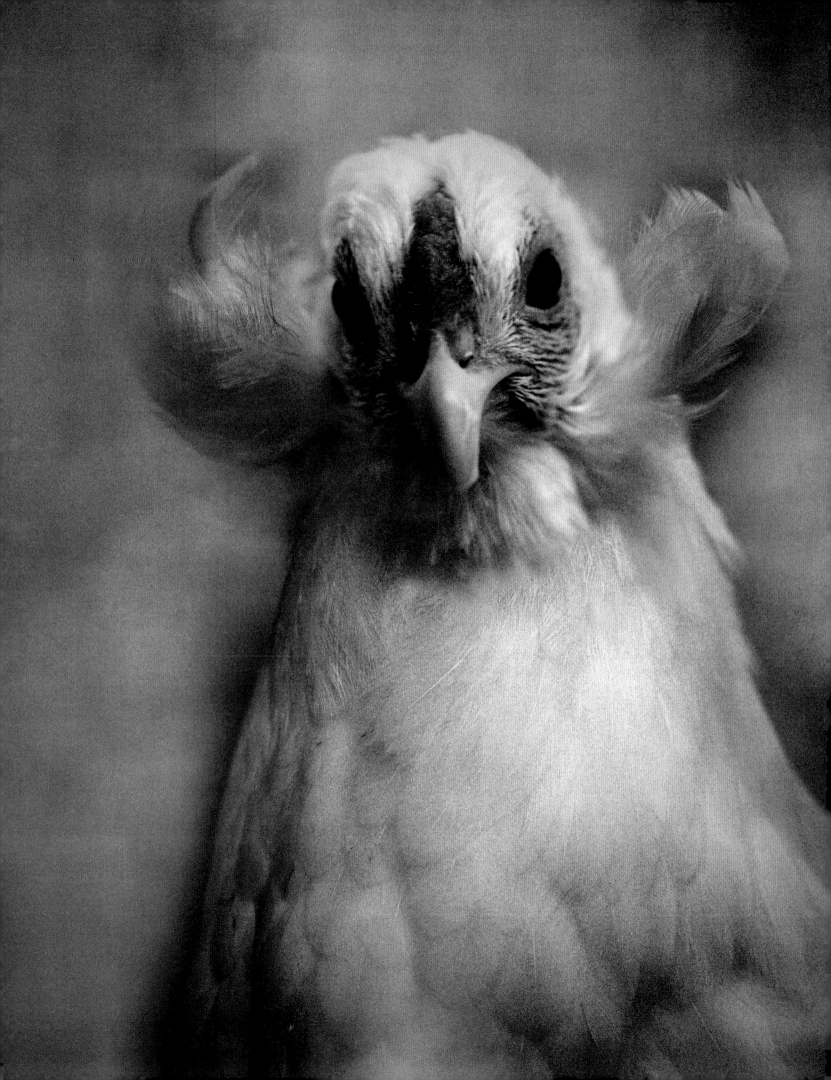

He talked to her endlessly about his love of horizontals: how they, the great levels of sky and land in Lincolnshire, meant to him the eternality of the will, just as the bowed Norman arches of the church, repeating themselves, meant the dogged leaping forward of the persistent human soul, on and on, nobody knows where.

—D. H. Lawrence, *Sons and Lovers* (1913)

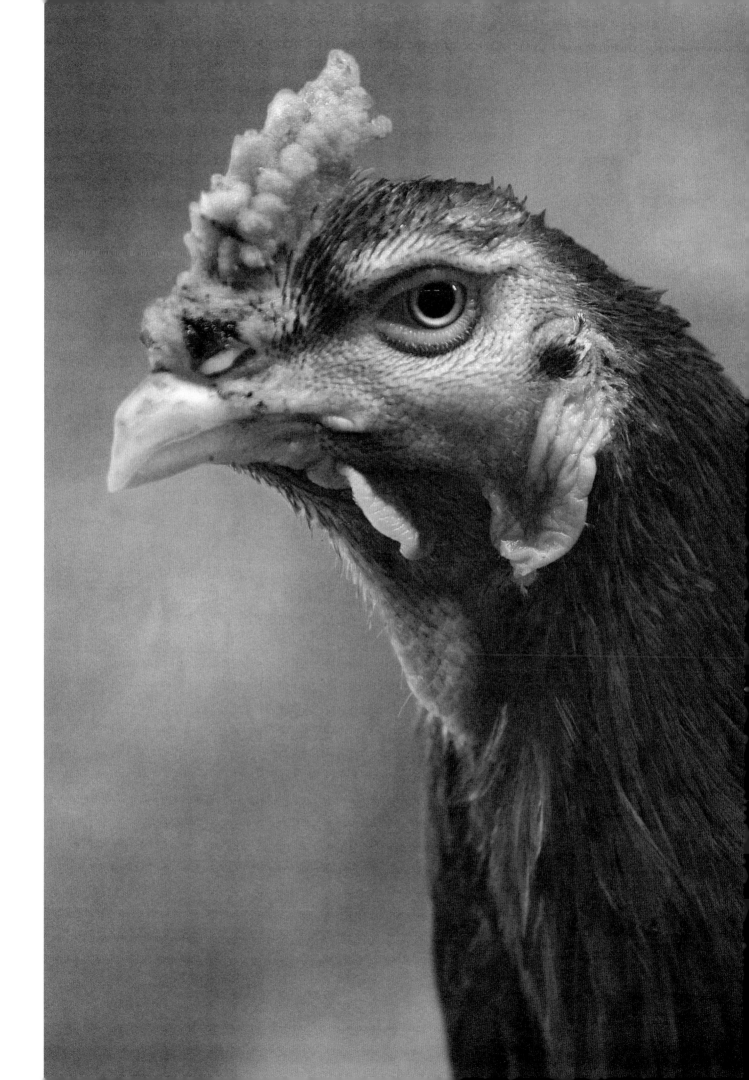

Could I ever have made them understand the emotion that I used to feel on winter mornings, when I met Mme. Swann on foot, in an otter-skin coat, with a woollen cap from which stuck out two blade-like partridge-feathers, but enveloped also in the deliberate, artificial warmth of her own house, which was suggested by nothing more than the bunch of violets crushed into her bosom, whose flowering, vivid and blue against the grey sky, the freezing air, the naked boughs, had the same charming effect of using the season and the weather merely as a setting, and of living actually in a human atmosphere, in the atmosphere of this woman, as had in the vases and beaupots of her drawing-room, beside the blazing fire, in front of the silk-covered sofa, the flowers that looked out through closed windows at the falling snow?

—Marcel Proust, *Swann's Way* (1913)

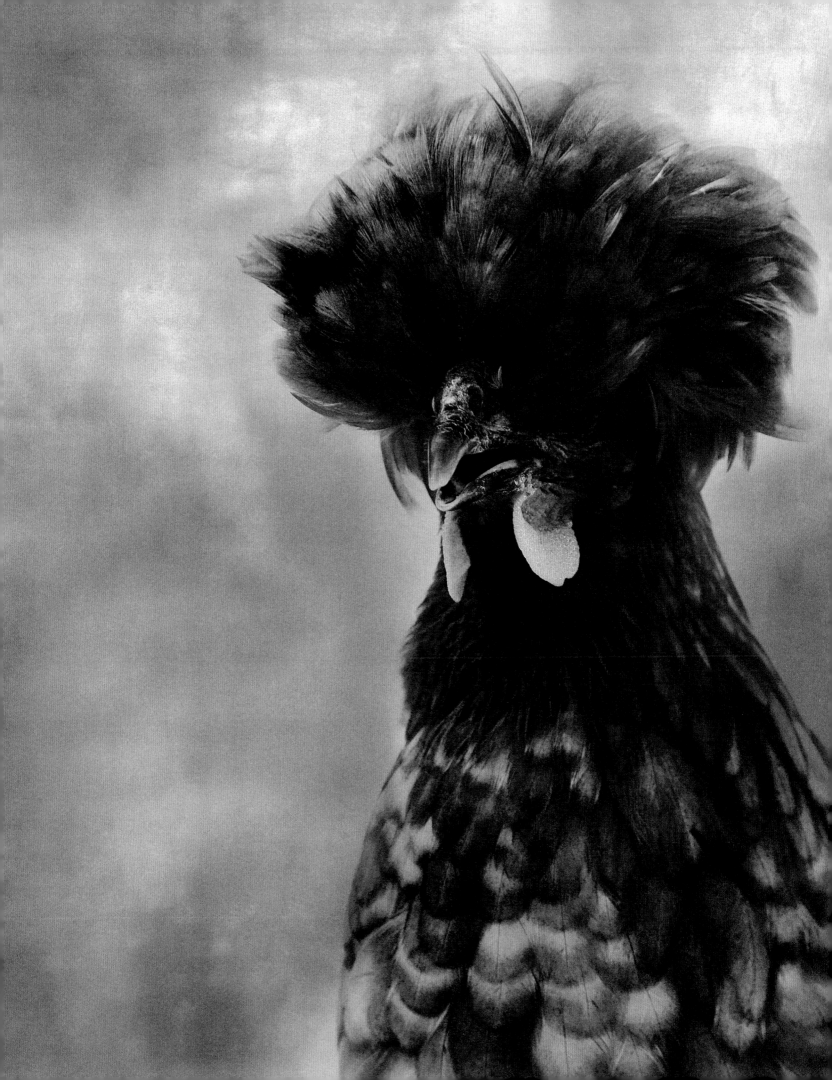

HIGGINS [indignantly] *I* swear! [Most emphatically] I never swear. I detest the habit. What the devil do you mean?

MRS. PEARCE [stolidly] That's what I mean, sir. You swear a great deal too much. I don't mind your damning and blasting, and what the devil and where the devil and who the devil—

HIGGINS Really! Mrs. Pearce: this language from your lips!

—George Bernard Shaw, *Pygmalion* (1913)

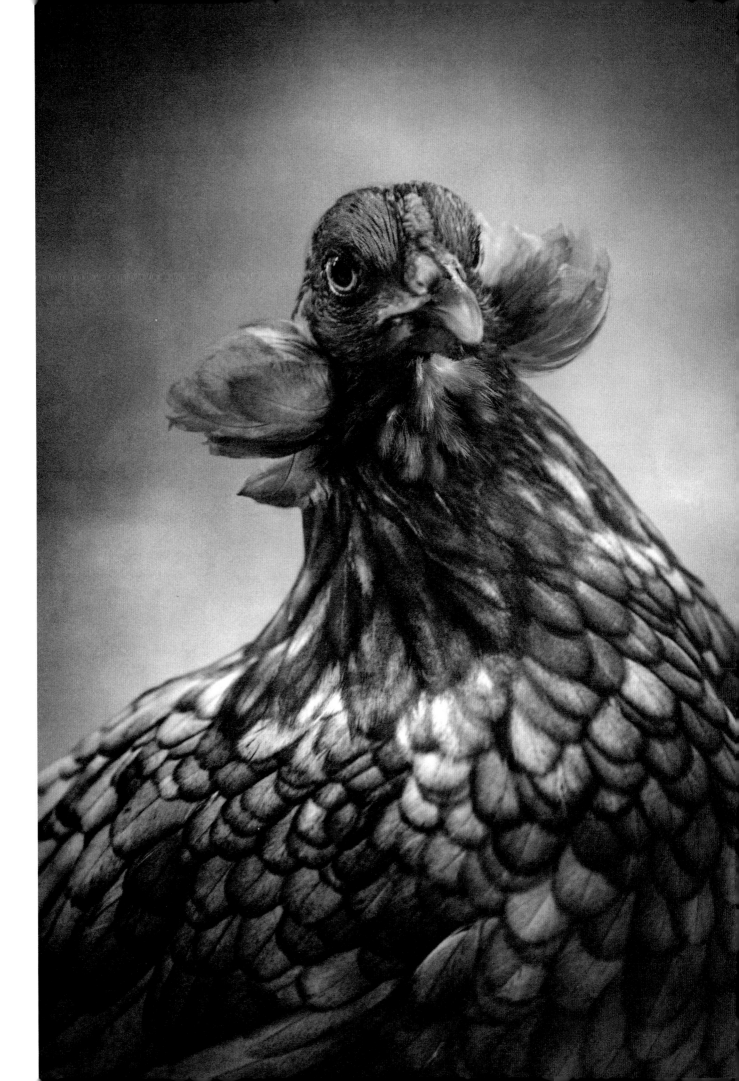

I've done my best to see you as you are, without any of this damned romantic nonsense. That was why I asked you here, and it's increased my folly. When you're gone I shall look out of that window and think of you. I shall waste the whole evening thinking of you. I shall waste my whole life, I believe."

—Virginia Woolf, *Night and Day* (1919)

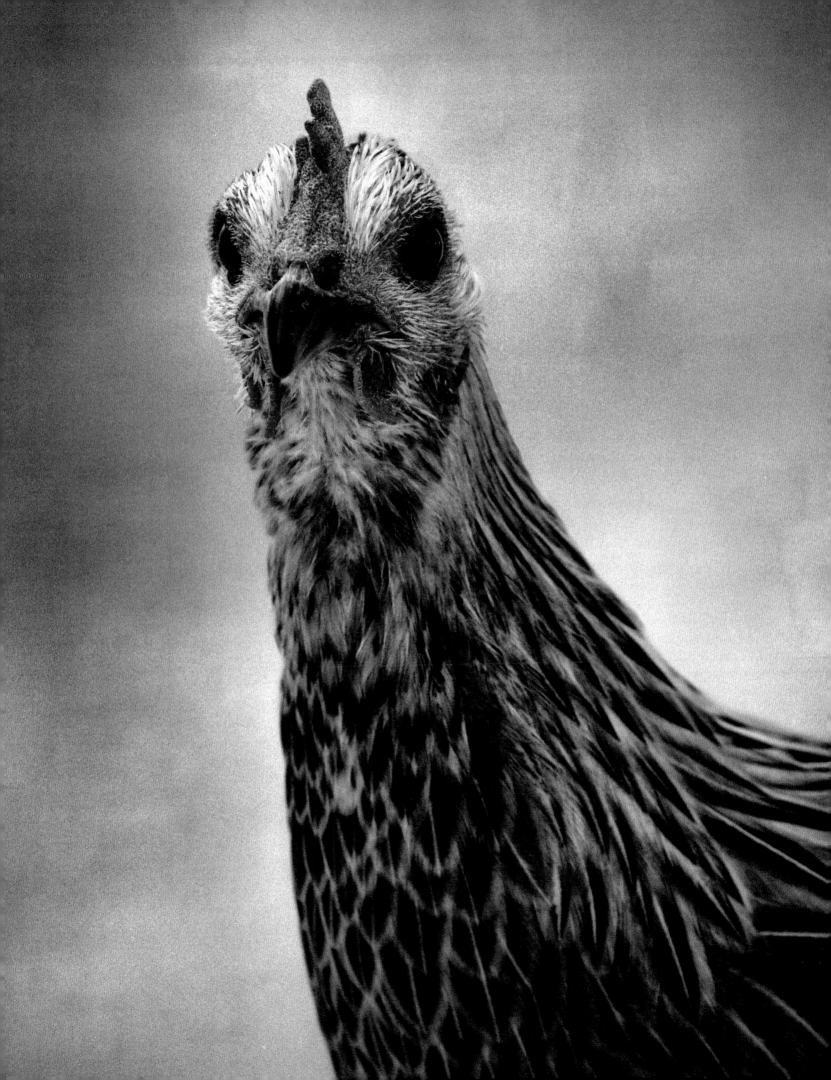

All in all Beatrice O'Hara absorbed the sort of education that will be quite impossible ever again; a tutelage measured by the number of things and people one could be contemptuous of and charming about; a culture rich in all arts and traditions, barren of all ideas, in the last of those days when the great gardener clipped the inferior roses to produce one perfect bud.

—F. Scott Fitzgerald,
This Side of Paradise (1920)

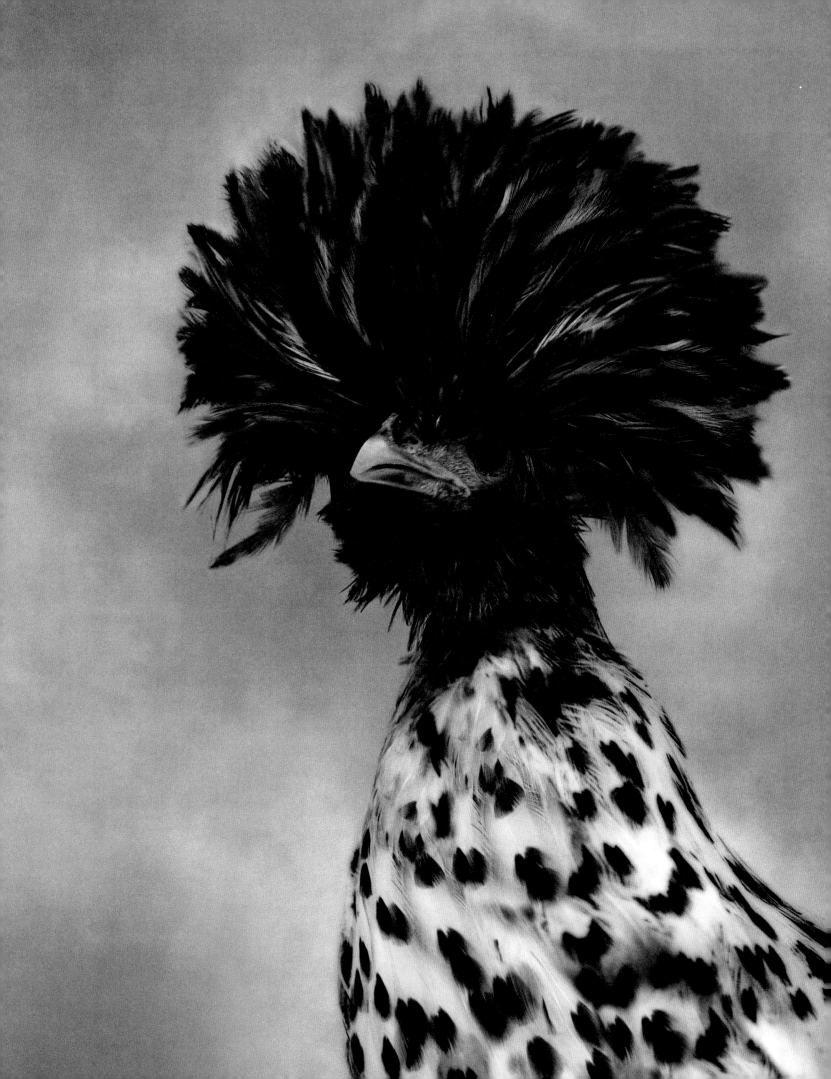

In the rotation of crops there was a recognized season for wild oats; but they were not sown more than once.

—Edith Wharton, *The Age of Innocence* (1920)

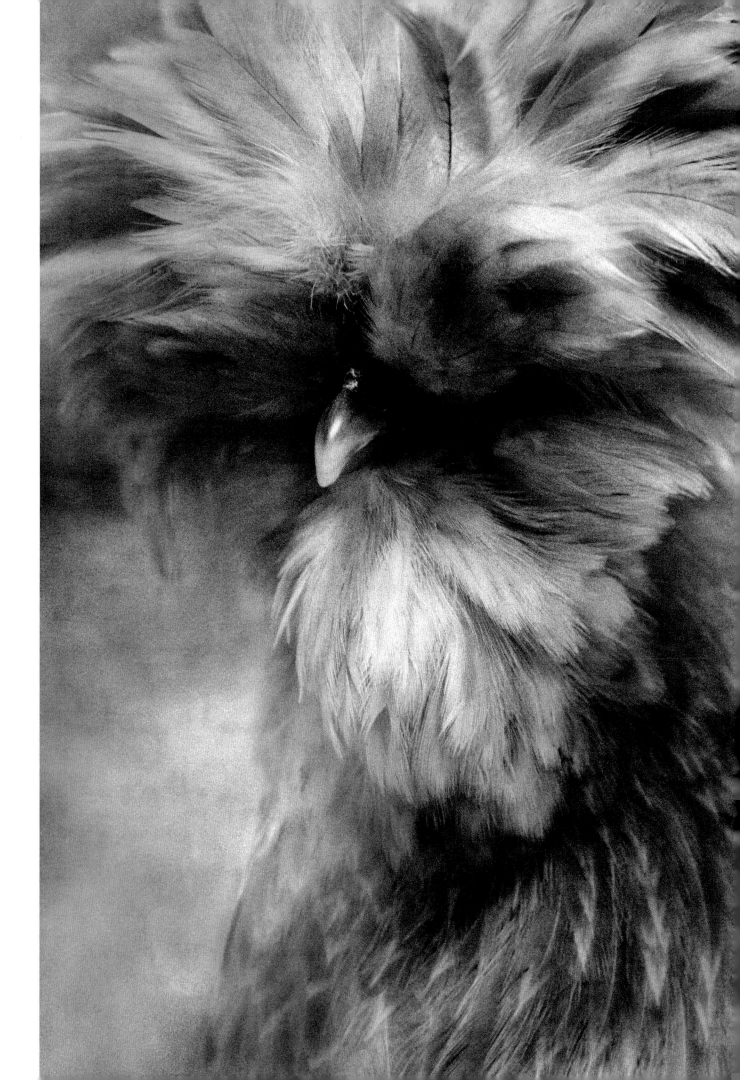

I've known rivers:

I've known rivers ancient as the world and older than the flow of human blood in human veins.

My soul has grown deep like the rivers.

—Langston Hughes,
"The Negro Speaks of Rivers" (1921)

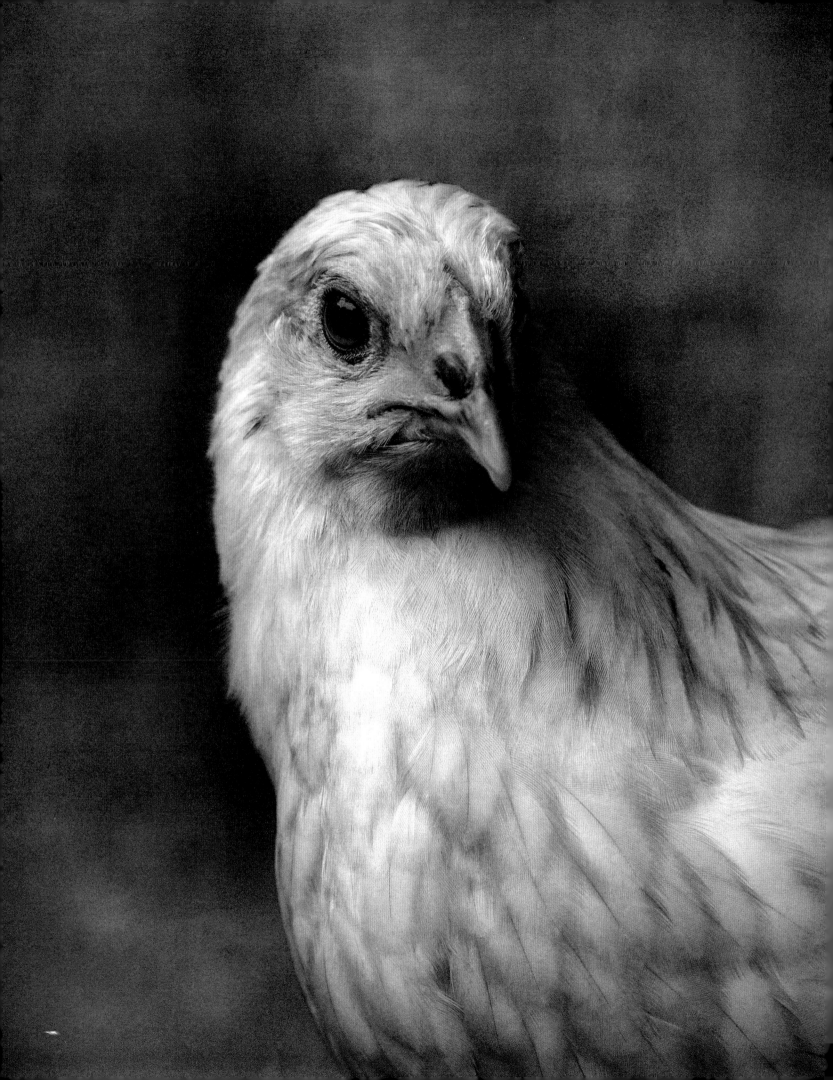

*I*n the shade of the house, in the sunshine of the riverbank near the boats, in the shade of the Sal-wood forest, in the shade of the fig tree is where Siddhartha grew up, the handsome son of the Brahman, the young falcon, together with his friend Govinda, son of a Brahman. The sun tanned his light shoulders by the banks of the river when bathing, performing the sacred ablutions, the sacred offerings.

—Herman Hesse, *Siddhartha* (1922)

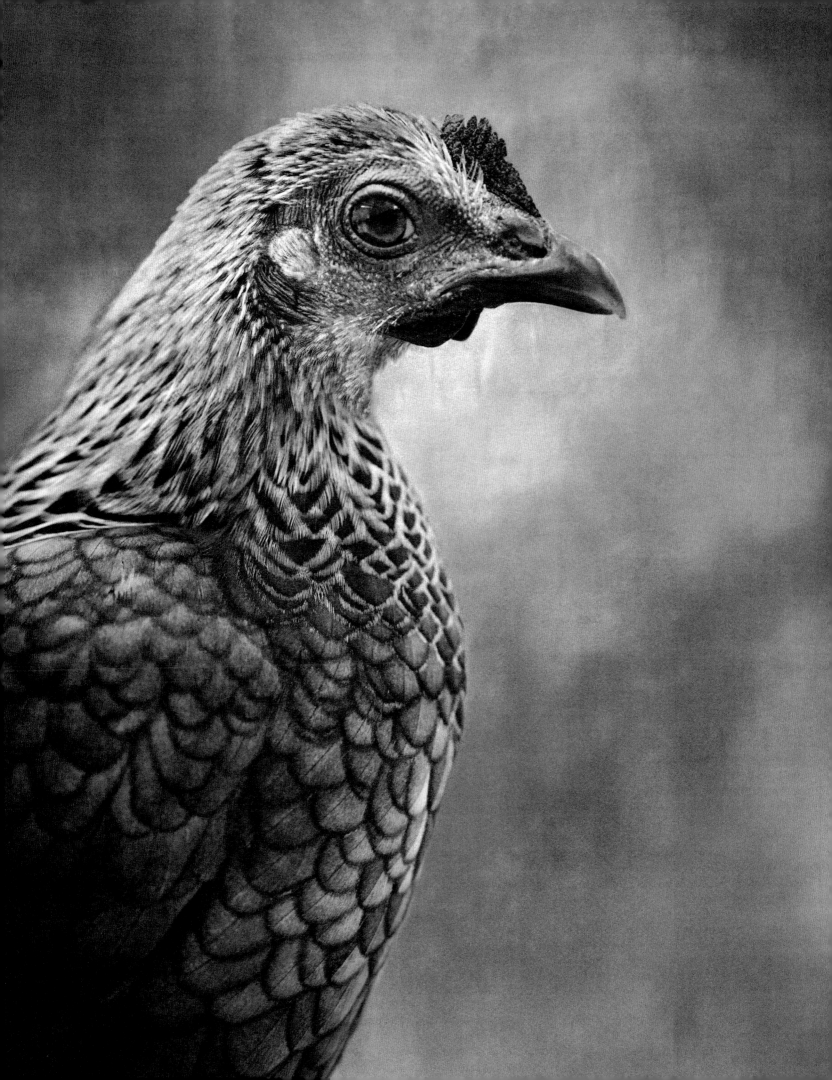

Stately, plump Buck Mulligan came from the stairhead, bearing a bowl of lather on which a mirror and a razor lay crossed. A yellow dressinggown, ungirdled, was sustained gently behind him on the mild morning air. He held the bowl aloft and intoned:

—*Introibo ad altare Dei.*

—James Joyce, *Ulysses* (1922)

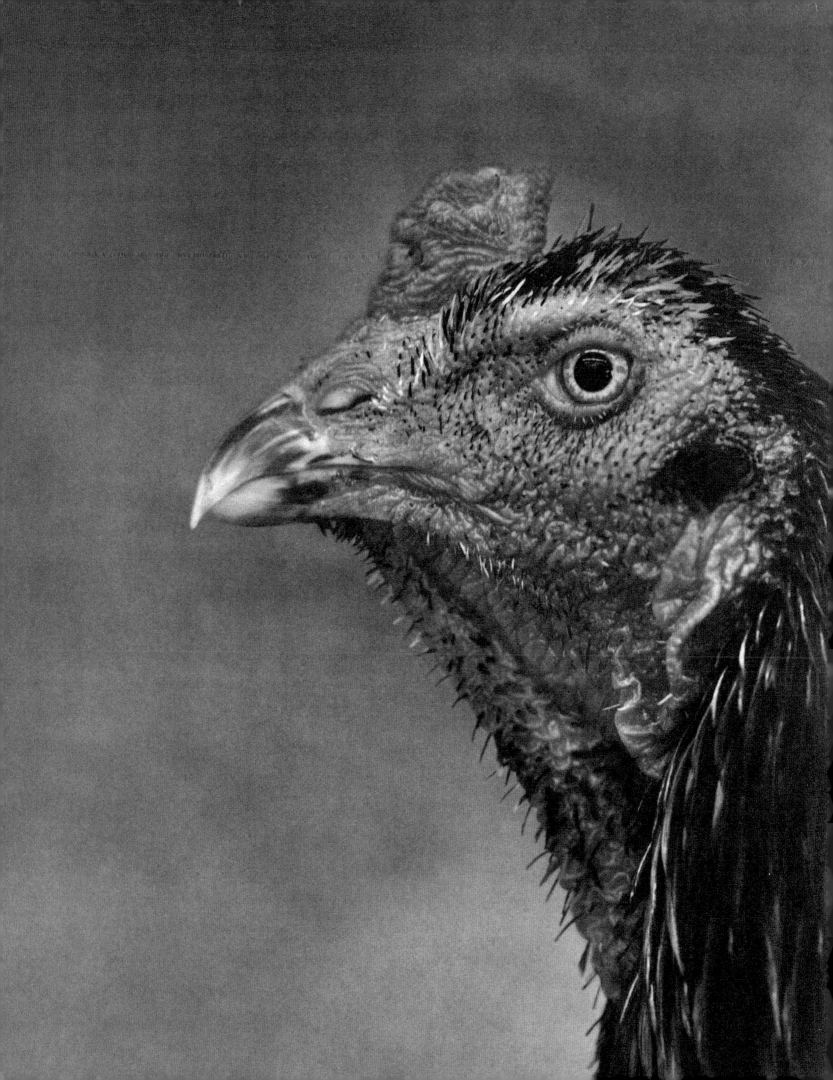

TOWARD A CULTURAL
HISTORY OF THE CHICKEN

BY COLLIER BROWN

The cultural legacy of chickens is all about fate, ours and theirs—a fate intertwined. Turn the pages of that legacy back far enough, and we find that our stories converge, quite literally. Scientists trace the common ancestor of chickens and humans back some three hundred million years. In the larger history of life on Earth, it's not such a great distance. In the history of literature, the connections draw us closer still. Before the twentieth century, ours was, as the art critic John Berger puts it, a language of fauna. We busied ourselves like bees. We worked like dogs. We cheated like snakes. We loved like doves. Animals explained (but mostly admonished) our strange, idealistic, and brutish behavior. Fables and myths rehearsed the antics of the fox, the wisdom of the owl, the persistence of the tortoise. And the chicken was Mother among mothers. Her maternal instincts were admired throughout the ages. In classical antiquity, for instance, we find writers like the Roman historian Plutarch who revered

> the manner in which hens care for their brood, drooping their wings for some to creep under, and receiving with joyous and affectionate clucks others that mount upon their backs or run up to them from every direction; and though they flee from dogs and snakes if they are frightened only for themselves, if their fright is for their children, they stand their ground and fight it out beyond their strength.[1]

But it wasn't just the chicken's pluck that earned respect. The ancient Romans practiced augury, the use of birds to predict the future. Chickens especially were consulted in matters of mortal consequence. The hens' verdicts were sacred. Feed would be scattered before the brood. If the chickens ate, then the omen was good. If not, then the task

[123]

at hand was to be abandoned. In a story told by Cicero, and often repeated, the Roman politician Publius Claudius Pulcher ignored the auguries of the chickens and suffered a major defeat during the First Punic War: "Claudius merely in jest mocked at the gods: when the chickens on being released from their cage refused to feed, he ordered them to be thrown into the water, so that as they would not eat they might drink; but the joke cost the jester himself many tears and the Roman people a great disaster, for the fleet was severely defeated."[2]

Fast-forward a couple millennia. Little remains of the chicken's affectionate tenacity in our pictures and metaphors. Modern chicken stories, in fact, tell mostly of bad luck and misery. In Ray Bradbury's short story "The Inspired Chicken Motel" (1969), a family drives west in a Buick, looking for work. It's 1932. The Depression is in full swing, and they are among millions scouring America's economic ruins for whatever nickels they can find. In Amarillo, Texas, the family pulls off the road at a chicken farm-cum-motel to rest. There, an elderly proprietress showcases a very unique egg. On the egg's surface, they see in relief the image of a longhorn bull. A second egg bears an epigraph: "Rest in Peace. Prosperity is near." The landlady tries to point out the hen that laid these remarkable eggs—"the white one . . . with the ginger flecks"[3]—but the family, gazing at the sea of chickens behind the farm's wire fence, can hardly pick out the one she means. The chicken's individuality is lost in the masses. The father shares the hen's plight. Maybe his talents will be discovered. Maybe someone will notice. Maybe the family will be okay. And maybe not.

In "The Egg," a classic story by Sherwood Anderson, chickens and hope are both dangerous commodities. A poor family from Ohio takes up chicken farming with hopes of future prosperity. But the business is a dirty one, tainted by death and disease. To that extent, Anderson's story is more nonfiction than fiction. For most of modern history, the chicken's life has been just as nasty, brutish, and short as any man's or woman's. Anderson's narrator, the chicken farmer's son, explains:

> One unversed in such matters can have no notion of the many and tragic things that can happen to a chicken. It is born out of an egg, lives for a few weeks as a tiny fluffy thing such as you will see pictured on Easter cards, then becomes hideously naked, eats quantities of corn and meal bought by the sweat of your father's brow, gets diseases called pip, cholera, and other

names, stands looking with stupid eyes at the sun, becomes sick and dies. A few hens and now and then a rooster, intended to serve God's mysterious ends, struggle through to maturity. The hens lay eggs out of which come other chickens and the dreadful cycle is thus made complete.[4]

After enduring this cycle for ten years, the family moves to town to open a restaurant instead. Business is slow, but the father thinks it might pick up if he starts amusing the customers with tricks. One night, he tries to entertain a guest by standing an egg on its narrow end. It doesn't work. He tries to soften the shell of an egg in vinegar to squeeze it into a bottle. That doesn't work. The son pities his father, and by the end, he too bears the weight of futility, passed down generation to generation—and symbolized, for this family, by a hen's egg.

Today's fables even dismiss the chicken's prophetic gifts as mere credulity. In the wartime Disney cartoon *Chicken Little* (1943), an aimless, yo-yo-toting chick receives some bad news from a voice over the farmyard fence. The sky is falling. The world is ending. Everyone is doomed. But wait, there's still a safe hiding place, whispers the villain, Foxy Loxy: a cave not far away has plenty of room for the entire flock. The other chickens are convinced by Chicken Little's hysterical chirping, and the masses flee right into Foxy Loxy's trap. In the end, the fat and happy fox picks his teeth with one of many wishbones planted upright in his cave, a morbid little orchard of death. Foxy Loxy's strategy, we should note, is not entirely of his own invention. Throughout the cartoon, he consults a manual of psychology. "To influence the masses," he reads, "aim first at the least intelligent"—recalling the methods of the era's real-life villains. In this case, the "least intelligent" targeted by Foxy Loxy is also the most vulnerable, the most innocent, the most naive—the child. The young are oracles too. They can imagine alternatives to the present, which makes them conduits of hope for us all. The fox slaughters the imagination, the wishbone, the divining rod of the future. There is no room for play and fantasy; only those grounded in prosaic reality can see through the fox's tricks.

Only a handful of artists in the past century have employed a positive image of the chicken. Perhaps the most famous of them would be William Carlos Williams, whose poem "The Red Wheelbarrow" has become required reading for any high school student:

so much depends
upon

a red wheel
barrow

glazed with rain
water

beside the white
chickens.

"No ideas but in things," Williams famously wrote, and here the chicken is a thing
among things, which speaks to the postindustrial spirit of the times. But as a thing that
has been singled out and named—as an image in a famous Imagist poem—the chicken
has at least been given a place of honor.

The fact is, our chicken typically plays a rather pedestrian role in art. Apart from
cameos in farm-related fiction, she rarely climbs the literary chain of being. And why
should she? As one of the world's most industrialized animals, the chicken has been
turned into a machine unsuited for poetry. Be that as it may, Williams makes a good
point. So much *does* depend on the chicken—so much more, in fact, than food and
commerce.

The chicken, after all, is as ubiquitous to human experience as the red wheelbarrow
glazed with rainwater. She is not just our future but our present, our every day. Henry
David Thoreau, prescient as always in matters ecological and aesthetic, made a connec-
tion between the chicken and "the moment" over one hundred fifty years ago. In his
essay "Walking" (1862), Thoreau wrote:

> Above all, we cannot afford not to live in the present. He is blessed over all
> mortals who loses no moment of the passing life in remembering the past.
> Unless our philosophy hears the cock crow in every barn-yard within our
> horizon, it is belated. That sound commonly reminds us that we are growing
> rusty and antique in our employments and habits of thought. His philoso-
> phy [the rooster's] comes down to a more recent time than ours. There is

something suggested by it not in Plato nor the New Testament. It is a newer testament—the Gospel according to this moment.[5]

What does the chicken have to say to us at this moment? Maybe something akin to what it has always said: that we're not so very different in the larger scheme of things? that we're both bound to the same place by the same needs? that our stories are inextricably linked?

Wistfulness for a lost zoological worldview may not help much at this point. As the novelist Thomas Wolfe famously said, "You can't go home again." But what is there to go back to? A world in which the chicken serves its utilitarian function, and when used up, is thrown to the foxes? If the fates of chickens and people are entangled, then the only future worth imagining is the one in which the chicken ascends to a higher state of appreciation—a future in which the hen warrants her own portrait for being a hen and not Eggland's best producer.

What type of birds typically have their portraits taken? Flipping through a few books and scanning the web, I start to see a pattern. It helps if you're a predator: a falcon, an eagle, a hawk: strong, majestic, fierce. Glamour doesn't hurt: the peacock adorned in Art Nouveau, the bird of paradise with its ostentatious tail. Endangered birds obviously make the list: the giant ibis, for instance, or the New Caledonian owlet-nightjar (whose name alone deserves a plaque). Not until an artist with a curious affection for the all-too-familiar comes along do we notice just how much there is to admire in a bird like the chicken.

Photographer Beth Moon is exactly that kind of artist. Inspired by John Berger's essay "Why Look at Animals?" and the writings of Michael Pollan, Moon developed a series of chicken portraits originally titled "Augurs and Soothsayers" and now gathered here as "Literary Chickens." The series draws attention to the great diversity of chickens that most of us never see. There is the Silver Spangled Appenzeller Spitzhauben, a Swiss breed with a shock of standing feathers along its crown like a Victorian lady's hat. There is the Buff Laced Polish with its extravagant pom-pom puffed out over its eyes. And there's my personal favorite, the Blue Silkie, fashionably coated in soft, fluffy steel-blue plumage. Nothing about the look of these birds suggests credulity. No Chicken Little here. Moon's portraits reclaim the ancient strangeness of this bird. These chickens are once again exotic, wondrous, and in terms of beauty, every bit the falcon's equal. Moon approaches her subjects as if they were the rarest of creatures. Each photograph

entertains an oracular eccentricity. I can't help but compare the literary and visual heritage of the chicken to Moon's tender, deferential portraits. And I can't help but wonder if that history deserves the title of "cultural" when so much of it has been about utility, service, efficiency. What the cultural history of chickens tells us is that *we need a cultural history of chickens*. Moon's photographs call the chickens back from the fox's den.

NOTES

1. Plutarch, *Moralia*, trans. W. C. Helmbold, vol. 6, Loeb Classical Library (Cambridge: Harvard University Press, 2014), 341.

2. Marcus Tullius Cicero, *De Natura Deorum; Academica*, Loeb Classical Library (Cambridge: Harvard University Press, 1933), 128–31, http://nrs.harvard.edu/urn-3:hul.ebookbatch.GEN_batch: LOEB14420150711.

3. Ray Bradbury, *The Stories of Ray Bradbury*, introduction by Christopher Buckley (New York: Knopf, 2010), 899. Susan Squier gives a great reading of this story in her study *Poultry Science, Chicken Culture: A Partial Alphabet* (New Jersey: Rutgers University Press, 2011), 19–33.

4. Sherwood Anderson, *Sherwood Anderson: Collected Stories*, ed. Charles Baxter (New York: Library of America, 2012), 231.

5. Henry David Thoreau, *Excursions*, ed. Joseph J. Moldenhauer (Princeton: Princeton University Press, 2007), 220; qtd. in Robert D. Richardson's essay "The Rooster's Philosophy," in *Thoreau at 200: Essays and Reassessments*, ed. Kristen Case (New York: Cambridge University Press, 2016), 200.

AFTERWORD

BY JANE GOODALL

I simply love Beth Moon's photographs. We know her for her stunning pictures of trees, but I am so delighted she has turned her talents toward chickens to create this stunning book.

I was born with a love of animals. When I was four and a half years old, my mother took me for a holiday on a farm belonging to my paternal grandmother. I was enchanted to come face-to-face with cows, pigs, and horses, all roaming in the fields. No factory farms in those days. I was given a job—to collect the eggs laid each day by the hens. Sometimes they made nests in the bushes, but mostly they laid their eggs in straw nests in the henhouses where they slept at night—to keep them safe from foxes. After a while I started to wonder where the egg came out of the hen—I could not see a hole that size. My mother told me I began asking everyone to explain, but no one did! What I remember clearly is seeing a brown hen going into one of the henhouses. I must have realized she was going to lay an egg, and crawled after her. Big mistake: she flew out with squawks of—of what? Fear? Indignation? Anyway, I must have realized no hen would lay in *that* henhouse. So I went into an empty one, hid in the straw, and waited. I was apparently gone about four hours! But my patience was rewarded: I saw a hen lay an egg! And there was the making of a little scientist: curiosity, asking questions, not getting the right answer, trying to find out for myself, making a mistake, not giving up, and learning patience. My very first ethological adventure.

When I first went to Africa in 1957, I heard of a farmer who was keeping hens in an indoor barn—the start of factory farming, perhaps. But he played classical music for them and let them out each morning to scratch around in the grass. Subsequently, of course, factory farming became more and more common: hens cramped in tiny cages, the tips of their beaks cut off, no straw on which to lie, just wire to sleep on. Stacked, cage on

cage. The smell. The noise. And not just hens. Pigs. Cows. Geese. Turkeys. After reading Peter Singer's *Animal Liberation*, I was sickened. The piece of meat on my plate symbolized Fear—Pain—Death. That was the last meat I ever ate.

Recently my sister Judy rescued six chickens whose usefulness in a factory farm was over. They were to be sold for soup or ground up for animal feed. They arrived almost featherless, and did not know what to do when allowed outside. But within a few days they started to explore, scratching about in the grass with those strong legs and feet, clucking, chasing insects—and each other. For very soon their individual personalities became clear, and they established a definite "pecking order" with Annabelle at the top of the hierarchy and Ethel at the bottom. Poor Ethel—I would not care to be a subordinate hen!

At first they were given the run of the whole garden, but they ate all the bulbs and vegetables, and so a large area was fenced off for them. Their feathers grew back, and they laid many eggs—but for the first two weeks we were told not to eat them, for they would still be contaminated with chemicals and antibiotics. Judy's hens lived a life of luxury, with the best chicken food and many treats in addition to the worms and snails they found for themselves.

And they taught Judy's two little grandsons what they needed to know: that animals have personalities, can think things out, and can feel contentment, depression, and fear.

ACKNOWLEDGMENTS

*W*ithout the assistance and kindness of many people, this work could not have been made. I extend great thanks to those who have been generous with their time and knowledge as well as those who have allowed me to photograph their birds: Kathy Dennison, Kirsten Jones-Neff, Priya Hemenway, François Hisquin, Tony Shroyer, Brian George, Valerie Charlton, Michelle Stern, Don Drake, Barry Brukoff, and Alexandra Matthews.

With gratitude to my family: Peter, Dylan, and my valuable assistants, Isabel and Alexandra. Their love of animals was clearly evident in the interest they showed and the patient way they handled the birds. I have the fondest memories of our time together on this project.

I am especially grateful for the voice of Dr. Jane Goodall. She believes in the power of art to effect change, is a fierce warrior who cares deeply for our world, and is a great inspiration to me. Her words add weight to the project, and it is an honor to have her writing included. Isabella Rossellini is a charming and generous woman who welcomed me to her extraordinary farm and introduced me to her heritage chickens. Her innovative farming methods teach by example. I greatly appreciate her support.

I would also like to extend my thanks to Collier Brown and Melissa Caughey for their moving and insightful essays.

I owe great thanks to the gallery owners who have represented me over the years: PH-Neutro in Verona and Siena, the Corden Potts Gallery in San Francisco, Photo-Eye Gallery in Santa Fe, Blin plus Blin in Paris, the Jennifer Kostuik Gallery in Vancouver, Zott Artspace in Singapore, Utópica in São Paulo, and the Vision Gallery in Jerusalem.

It has been a privilege for me to work with Bob Abrams and the truly exceptional team at Abbeville Press: Misha Beletsky, Louise Kurtz, Julia Judge, Matt Garczynski, Emily Mullen, and David Fabricant. I am profoundly grateful for the commitment and care they have invested in this book. It has been a pleasure to work on our third book together.

Kindest thanks to Jedd Dwight from the Poultry Club of Great Britain for his assistance in identifying the pictured breeds of chicken. Needless to say, he bears no responsibility for any errors.

And lastly, I would like to thank everyone at Mercy for Animals, a great nonprofit organization that I support, whose hard work and dedication have made great strides in preventing cruelty to farmed animals and promoting compassionate food choices.

Thank you all!

BREEDS PICTURED

Page 19 (Anonymous, *Beowulf*): White Faced Black Spanish male

Page 21 (Chaucer, *The Canterbury Tales*): Single Comb White Leghorn female

Page 23 (Machiavelli, *The Prince*): Old English (?) Game male

Page 25 (Cervantes, *Don Quixote*): White Crested Splash Polish male

Page 27 (Shakespeare, Sonnet 130): Silver Spangled Hamburg female

Page 29 (Milton, *Paradise Lost*): Wheaten Shamo female

Page 31 (Swift, *Gulliver's Travels*): Frizzle male

Page 33 (Voltaire, *Candide*): Kulang Asil male

Page 35 (Goethe, *Faust*): Dark Brahma female

Page 37 (Blake, "The Lilly"): White Sultan male

Page 39 (Austen, *Pride and Prejudice*): Single Comb White Leghorn female

Page 41 (Byron, "She Walks in Beauty"): Salmon Faverolles female

Page 43 (Stendhal, *The Red and the Black*): Single Comb Light Brown Leghorn female

Page 45 (Balzac, *Eugenie Grandet*): Black Cochin male

Page 47 (Pushkin, "The Queen of Spades"): Golden Sebright male

Page 49 (Dumas, *The Count of Monte Cristo*): Ameraucana female

Page 51 (Brontë, *Wuthering Heights*): Dark Brahma female

Page 53 (Thackeray, *Vanity Fair*): Black Cochin female

Page 55 (Hawthorne, *The Scarlet Letter*): Jubilee Cornish female

Page 57 (Dickens, *David Copperfield*): Blue Andalusian female

Page 59 (Melville, *Moby-Dick*): Old English Game male

Page 61 (Flaubert, *Madame Bovary*): Silver Sebright female

Page 63 (Dickens, *Great Expectations*): Serama female

Page 65 (Hugo, *Les Misérables*): Mottled Java female

Page 67 (Alcott, *Little Women*): Single Comb Black Minorca female

Page 69 (Tolstoy, *War and Peace*): Quail Belgian Bearded d'Anvers female

Page 71 (Eliot, *Middlemarch*): Silver Spangled Appenzeller Spitzhauben female

Page 73 (Twain, *The Adventures of Tom Sawyer*): Reza Asil male

Page 75 (Dostoyevsky, *The Brothers Karamazov*): Black Sumatra female

Page 77 (James, *The Portrait of a Lady*): Quail Belgian Bearded d'Anvers female

Page 79 (Whitman, "Miracles"): Egyptian Fayoumi female (?)

Page 81 (Stevenson, *Treasure Island*): Russian Orloff male

Page 83 (Kipling, "The Man Who Would Be King"): Silver Pavlov male

Page 85 (Jerome, *Three Men in a Boat*): Silver Sebright female

Page 87 (Dickinson, "The butterfly's assumption-gown"): Frizzle female

Page 89 (Doyle, "A Scandal in Bohemia"): Bearded Buff Laced Polish female

Page 91 (Wilde, *The Importance of Being Earnest*): Sicilian Buttercup female

Page 93 (Stoker, *Dracula*): Modern Game male

Page 95 (Baum, *The Wonderful Wizard of Oz*): Bearded Buff Laced Polish male

Page 97 (Rilke, "Maidens I"): Mille Fleur Belgian Bearded d'Uccle male

Page 99 (London, *The Call of the Wild*): Welsummer female

Page 101 (Forster, *A Room with a View*): Bearded Blue Silkie female

Page 103 (Barrie, *Peter Pan*): White Rumpless Araucana female

Page 105 (Lawrence, *Sons and Lovers*): Reza Asil male

Page 107 (Proust, *Swann's Way*): Blue Polish female

Page 109 (Shaw, *Pygmalion*): Blue Rumpless Araucana female

Page 111 (Woolf, *Night and Day*): Silver Phoenix female

Page 113 (Fitzgerald, *This Side of Paradise*): Black Crested Polish female

Page 115 (Wharton, *The Age of Innocence*): Bearded Buff Laced Polish female (?)

Page 117 (Hughes, "The Negro Speaks of Rivers"): White Ameraucana female

Page 119 (Hesse, *Siddhartha*): Silver Blue Modern Game female

Page 121 (Joyce, *Ulysses*): Shamo male

WORKS QUOTED

Serialized novels are cited in their first edition in book form.

Alcott, Louisa May. *Little Women*. Boston: Roberts Brothers, 1869.

Austen, Jane. *Pride and Prejudice*. London: T. Egerton, 1813.

Balzac, Honore de. *Eugénie Grandet*. Paris: Mme. Charles-Béchet, 1833. Translated by Katherine Prescott Wormeley (Boston: Roberts Brothers, 1889).

Barrie, J. M. *Peter Pan*. London: Hodder & Stoughton; New York: Charles Scribner's Sons, 1911.

Baum, L. Frank. *The Wonderful Wizard of Oz*. Chicago: George M. Hill Company, 1900.

Beowulf. Translated by F. B. Gummere. New York: P.F. Collier and Son, 1910.

Blake, William. "The Lilly." In *Songs of Innocence and of Experience*. Self-published, 1794.

Brontë, Emily. *Wuthering Heights*. London: Thomas Cautley Newby, 1847.

Byron, George Gordon, Lord. "She Walks in Beauty." In *Hebrew Melodies*, 3–4. London: John Murray, 1815.

Cervantes, Miguel de. *El Ingenioso Hidalgo Don Quijote de la Mancha*. Madrid: Francisco de Robles, 1605. Translated by John Ormsby as *Don Quixote* (London: Smith, Elder, & Co., 1885).

Chaucer, Geoffrey. *The Canterbury Tales*. London: William Caxton, 1476.

Dickens, Charles. *David Copperfield*. London: Bradbury & Evans, 1850.

Dickens, Charles. *Great Expectations*. London: Chapman & Hall, 1861.

Dickinson, Emily. "The butterfly's assumption-gown." In *Poems by Emily Dickinson*, 95. Edited by Mabel Loomis Todd and T. W. Higginson. Boston: Roberts Brothers, 1890.

Dostoyevsky, Fyodor. *Brat'ya Karamazovy*. St Petersburg: Brothers Panteleev, 1881. Translated by Constance Garnett as *The Brothers Karamazov* (London: Heinemann, 1912).

Doyle, Sir Arthur Conan. "A Scandal in Bohemia." *The Strand Magazine*, July 1891.

Dumas, Alexandre. *Le Comte de Monte-Cristo*. Paris: Pétion, 1845–46. Translated as *The Count of Monte Cristo* (London: Chapman & Hall, 1846).

Eliot, George. *Middlemarch. A Study of Provincial Life*. Edinburgh: William Blackwood and Sons, 1871.

Fitzgerald, F. Scott. *This Side of Paradise*. New York: Scribner, 1920.

Flaubert, Gustave. *Madame Bovary*. Paris: Michel Lévy Frères. Translated by Francis Steegmuller (New York: Random House, 1957).

Forster, E. M. *A Room with a View*. London: Edward Arnold, 1908.

Goethe, Johann Wolfgang von. *Faust*. Tübingen, 1808. Translated by Bayard Taylor (Boston: James R. Osgood, 1870–71).

Hawthorne, Nathaniel. *The Scarlet Letter*. Boston: Ticknor, Reed & Fields, 1850.

Hesse, Hermann. *Siddhartha*. Berlin: S. Fischer Verlag, 1922. Translated by Gunther Olesch, Anke Dreher, Amy Coulter, Stefan Langer, and Semyon Chaichenets (Project Gutenberg, 2008), http://www.gutenberg.org/ebooks/2500.

Hughes, Langston. "The Negro Speaks of Rivers." *The Crisis*, June 1921.

Hugo, Victor. *Les Misérables*. Brussels: Librairie internationale A. Lacroix, Verboeckhoven, et Cie., 1862. Translated by Charles E. Wilbour (New York: Carleton Publishing Company, 1862).

James, Henry. *The Portrait of a Lady*. Boston: Houghton, Mifflin and Company; London: MacMillan and Co., 1881.

Jerome, Jerome K. *Three Men in a Boat*. Bristol: J. W. Arrowsmith, 1889.

Joyce, James. *Ulysses*. Paris: Sylvia Beach, 1922.

Kipling, Rudyard. "The Man Who Would Be King." In *The Phantom Rickshaw and Other Eerie Tales*, 7–31. Allahabad: A. H. Wheeler & Co., 1888.

Lawrence, D. H. *Sons and Lovers*. London: Gerald Duckworth and Company Ltd., 1913.

London, Jack. *The Call of the Wild*. New York: Macmillan, 1903.

Machiavelli, Nicolo. *Il Principe*. Rome: Antonio Blado d'Asola, 1532. Translated by W. K. Marriott as *The Prince* (London: J. M. Dent & Company, 1908).

Melville, Herman. *Moby-Dick; or The Whale*. London: Richard Bentley; New York: Harper, 1851.

Milton, John. *Paradise Lost*. London: Samuel Simmons, 1667.

Proust, Marcel. *Du côté de chez Swann*. Paris: Bernard Grasset, 1913. Translated by C. K. Scott Moncrieff as *Swann's Way* (London: Chatto & Windus, 1922).

Pushkin, Alexander. "Pikovaya dama." *Biblioteka dlya chteniya*, March 1834. Translated by H. Twitchell as *The Queen of Spades* (New York: The Current Literature Publishing Company, 1901).

Rilke, Rainer Maria. "Von Den Mädchen I." In *Das Buch der Bilder*. Berlin: Axel Juncker Verlag, 1902. Translated by Jessie Lemont as "Maidens I" in *Poems by Rainer Maria Rilke* (New York: T. A. Wright, 1918).

Shakespeare, William. Sonnet 130. In *Shake-speares Sonnets: Never Before Imprinted*. London: Thomas Thorpe, 1609.

Shaw, George Bernard. *Pygmalion*. *Everybody's Magazine*, November 1914.

Stendahl. *Le Rouge et le Noir*. Paris: A. Levasseur, 1830. Translated by Horace B. Samuel as *The Red and the Black* (London: Kegan Paul, Trench Trübner & Co., Ltd.; New York: E.P. Dutton and Co., 1916).

Stevenson, Robert Louis. *Treasure Island*. London: Cassell and Company, 1883.

Stoker, Bram. *Dracula*. London: Archibald Constable and Company, 1897.

Swift, Jonathan. *Travels into Several Remote Nations of the World. In Four Parts. By Lemuel Gulliver, First a Surgeon, and Then a Captain of Several Ships*. London: Benjamin Motte, 1726.

Thackery, William Makepeace. *Vanity Fair*. London: Bradbury & Evans, 1848.

Tolstoy, Leo. *Voyná i mir*. Moscow: T. Ris, 1868–69. Translated by Aylmer and Louise Maude as *War and Peace* (London: Dent, 1922–23).

Twain, Mark. *The Adventures of Tom Sawyer*. Hartford: American Publishing Company, 1876.

Voltaire. *Candide, ou l'Optimisme*. Paris: Sirène, 1759. Translated by Philip Littell (New York: Boni & Liveright, 1918).

Wharton, Edith. *The Age of Innocence*. New York: D. Appleton & Company, 1920.

Whitman, Walt. "Miracles." *Leaves of Grass*. New York: Fowler & Wells, 1856.

Wilde, Oscar. *The Importance of Being Earnest*. London: Leonard Smithers, 1898.

Woolf, Virginia. *Night And Day*. London: Duckworth, 1919.